Francis Frith's
Bedfordshire

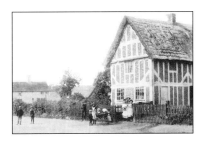

Photographic Memories

Francis Frith's
Bedfordshire

Derryck Draper

FRITH
BOOK Co

First published in the United Kingdom in 2001 by
Frith Book Company Ltd

Hardback Edition 2001
ISBN 1-85937-320-8

British Library Cataloguing in Publication Data

Francis Frith's Bedfordshire
Derryck Draper

Frith Book Company Ltd
Frith's Barn, Teffont,
Salisbury, Wiltshire SP3 5QP
Tel: +44 (0) 1722 716 376
Email: info@francisfrith.co.uk
www.francisfrith.co.uk

Printed and bound in Great Britain

Front Cover: Totternhoe, The Village 1897 39754

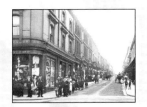

Contents

Francis Frith: *Victorian Pioneer*

FRANCIS FRITH, Victorian founder of the world-famous photographic archive, was a complex and multi-talented man. A devout Quaker and a highly successful Victorian businessman, he was both philosophic by nature and pioneering in outlook.

By 1855 Francis Frith had already established a wholesale grocery business in Liverpool, and sold it for the astonishing sum of £200,000, which is the equivalent today of over £15,000,000. Now a multi-millionaire, he was able to indulge his passion for travel. As a child he had pored over travel books written by early explorers, and his fancy and imagination had been stirred by family holidays to the sublime mountain regions of Wales and Scotland. 'What a land of spirit-stirring and enriching scenes and places!' he had written. He was to return to these scenes of grandeur in later years to 'recapture the thousands of vivid and tender memories', but with a different purpose. Now in his thirties, and captivated by the new science of photography, Frith set out on a series of pioneering journeys to the Nile regions that occupied him from 1856 until 1860.

Intrigue and Adventure

He took with him on his travels a specially-designed wicker carriage that acted as both dark-room and sleeping chamber. These far-flung journeys were packed with intrigue and adventure. In his life story, written when he was sixty-three, Frith tells of being held captive by bandits, and of fighting 'an awful midnight battle to the very point of surrender with a deadly pack of hungry, wild dogs'. Sporting flowing Arab costume, Frith arrived at Akaba by camel seventy years before Lawrence, where he encountered 'desert princes and rival sheikhs, blazing with jewel-hilted swords'.

During these extraordinary adventures he was assiduously exploring the desert regions bordering the Nile and patiently recording the antiquities and peoples with his camera. He was the first photographer to venture beyond the sixth cataract. Africa was still the mysterious 'Dark Continent', and Stanley and Livingstone's historic meeting was a decade into the future. The conditions for picture taking confound belief. He laboured for hours in his wicker dark-room in the sweltering heat of the desert, while the volatile chemicals fizzed dangerously in their trays. Often he was forced to work in remote tombs and caves where conditions were cooler. Back in London he exhibited his photographs and was 'rapturously cheered' by members of the Royal Society. His reputation as a

photographer was made overnight. An eminent modern historian has likened their impact on the population of the time to that on our own generation of the first photographs taken on the surface of the moon.

Venture of a Life-Time

Characteristically, Frith quickly spotted the opportunity to create a new business as a specialist publisher of photographs. He lived in an era of immense and sometimes violent change. For the poor in the early part of Victoria's reign work was a drudge and the hours long, and people had precious little free time to enjoy themselves. Most had no transport other than a cart or gig at their disposal, and had not travelled far beyond the boundaries of their own town or village. However,

by the 1870s, the railways had threaded their way across the country, and Bank Holidays and half-day Saturdays had been made obligatory by Act of Parliament. All of a sudden the ordinary working man and his family were able to enjoy days out and see a little more of the world.

With characteristic business acumen, Francis Frith foresaw that these new tourists would enjoy having souvenirs to commemorate their days out. In 1860 he married Mary Ann Rosling and set out with the intention of photographing every city, town and village in Britain. For the next thirty years he travelled the country by train and by pony and trap, producing fine photographs of seaside resorts and beauty spots that were keenly bought by millions of Victorians. These prints were painstakingly pasted into family albums and pored over during the dark nights of winter, rekindling precious memories of summer excursions.

The Rise of Frith & Co

Frith's studio was soon supplying retail shops all over the country. To meet the demand he gathered about him a small team of photographers, and published the work of independent artist-photographers of the calibre of Roger Fenton and Francis Bedford. In order to gain some understanding of the scale of Frith's business one only has to look at the catalogue issued by Frith & Co in 1886: it runs to some 670 pages, listing not only many thousands of views of the British Isles but also many photographs of most European countries, and China, Japan, the USA and Canada – note the sample page shown above from the hand-written *Frith & Co* ledgers detailing pictures taken. By 1890 Frith had created the greatest specialist photographic publishing company in the world,

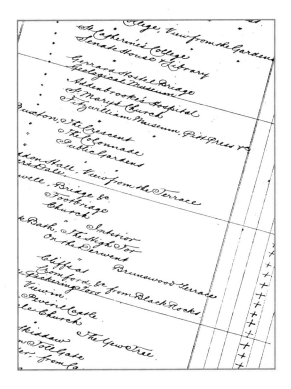

with over 2,000 outlets – more than the combined number that Boots and W H Smith have today! The picture on the right shows the *Frith & Co* display board at Ingleton in the Yorkshire Dales. Beautifully constructed with mahogany frame and gilt inserts, it could display up to a dozen local scenes.

Postcard Bonanza

The ever-popular holiday postcard we know today took many years to develop. In 1870 the Post Office issued the first plain cards, with a pre-printed stamp on one face. In 1894 they allowed other publishers' cards to be sent through the mail with an attached adhesive halfpenny stamp. Demand grew rapidly, and in 1895 a new size of postcard was permitted called the court card, but there was little room for illustration. In 1899, a year after

Frith's death, a new card measuring 5.5 x 3.5 inches became the standard format, but it was not until 1902 that the divided back came into being, with address and message on one face and a full-size illustration on the other. *Frith & Co* were in the vanguard of postcard development, and Frith's sons Eustace and Cyril continued their father's monumental task, expanding the number of views offered to the public and recording more and more places in Britain, as the coasts and countryside were opened up to mass travel.

Francis Frith died in 1898 at his villa in Cannes, his great project still growing. The archive he created continued in business for another seventy years. By 1970 it contained over a third of a million pictures of 7,000 cities, towns and villages. The massive photographic record Frith has left to us stands as a living monument to a special and very remarkable man.

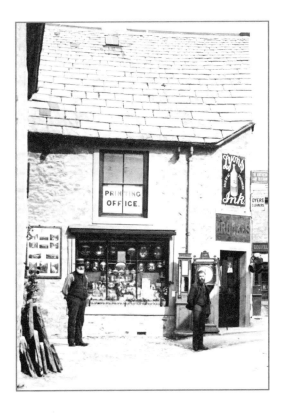

Frith's Archive: *A Unique Legacy*

FRANCIS FRITH'S legacy to us today is of immense significance and value, for the magnificent archive of evocative photographs he created provides a unique record of change in 7,000 cities, towns and villages throughout Britain over a century and more. Frith and his fellow studio photographers revisited locations many times down the years to update their views, compiling for us an enthralling and colourful pageant of British life and character.

We tend to think of Frith's sepia views of Britain as nostalgic, for most of us use them to conjure up memories of places in our own lives with which we have family associations. It often makes us forget that to Francis Frith they were records of daily life as it was actually being lived in the cities, towns and villages of his day. The Victorian age was one of great and often bewildering change for ordinary people, and though the pictures evoke an impression of slower times, life was as busy and hectic as it is today.

We are fortunate that Frith was a photographer of the people, dedicated to recording the minutiae of everyday life. For it is this sheer wealth of visual data, the painstaking chronicle of changes in dress, transport, street layouts, buildings, housing, engineering and landscape that captivates us so much today. His remarkable images offer us a powerful link with the past and with the lives of our ancestors.

Today's Technology

Computers have now made it possible for Frith's many thousands of images to be accessed almost instantly. In the Frith archive today, each photograph is carefully 'digitised' then stored on a CD Rom. Frith archivists can locate a single photograph amongst thousands within seconds. Views can be catalogued and sorted under a variety of categories of place and content to the immediate benefit of researchers.

Inexpensive reference prints can be created for them at the touch of a mouse button, and a wide range of books and other printed materials assembled and published for a wider, more general readership - in the next twelve months over a hundred Frith local history titles will be published! The day-to-day workings of the archive are very different from how they were in Francis Frith's time: imagine the herculean task of sorting through eleven tons of glass negatives as Frith had to do to locate a particular sequence of pictures! Yet

See Frith at www.francisfrith.co.uk

the archive still prides itself on maintaining the same high standards of excellence laid down by Francis Frith, including the painstaking cataloguing and indexing of every view.

It is curious to reflect on how the internet now allows researchers in America and elsewhere greater instant access to the archive than Frith himself ever enjoyed. Many thousands of individual views can be called up on screen within seconds on one of the Frith internet sites, enabling people living continents away to revisit the streets of their ancestral home town, or view places in Britain where they have enjoyed holidays. Many overseas researchers welcome the chance to view special theme selections, such as transport, sports, costume and ancient monuments.

We are certain that Francis Frith would have heartily approved of these modern developments in imaging techniques, for he himself was always working at the very limits of Victorian photographic technology.

The Value of the Archive Today

Because of the benefits brought by the computer, Frith's images are increasingly studied by social historians, by researchers into genealogy and ancestory, by architects, town planners, and by teachers and schoolchildren involved in local history projects.

In addition, the archive offers every one of us an opportunity to examine the places where we and our families have lived and worked down the years. Highly successful in Frith's own era, the archive is now, a century and more on, entering a new phase of popularity.

The Past in Tune with the Future

Historians consider the Francis Frith Collection to be of prime national importance. It is the only archive of its kind remaining in private ownership and has been valued at a million pounds. However, this figure is now rapidly increasing as digital technology enables more and more people around the world to enjoy its benefits.

Francis Frith's archive is now housed in an historic timber barn in the beautiful village of Teffont in Wiltshire. Its founder would not recognize the archive office as it is today. In place of the many thousands of dusty boxes containing glass plate negatives and an all-pervading odour of photographic chemicals, there are now ranks of computer screens. He would be amazed to watch his images travelling round the world at unimaginable speeds through network and internet lines.

The archive's future is both bright and exciting. Francis Frith, with his unshakeable belief in making photographs available to the greatest number of people, would undoubtedly approve of what is being done today with his lifetime's work. His photographs, depicting our shared past, are now bringing pleasure and enlightenment to millions around the world a century and more after his death.

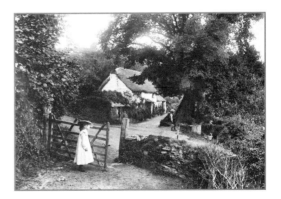

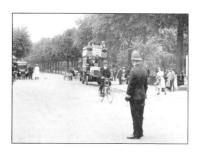

Bedfordshire - *An Introduction*

FOR MILLENNIA, the part of Britain that we identify as the English county of Bedfordshire has been a through-route to the rest of the British islands. Cattle, flints, salt, iron implements and, latterly, trade goods from Gaul and the Mediterranean were traded across the country from Wessex to the Wash and back again via the route of the ancient Icknield Way. The Belgae began a wave-like invasion across the Channel and through Kent around 75 BC. They established a stronghold at St Albans (Verulamium), and used existing trackways to probe further north into the fertile lands of the Great Ouse and Lea valleys. The Romans pushed three major routes north by strengthening and fortifying the existing Watling Street and Ermine Street ridge-bound ways, incorporating a series of ancillary byways or summer-ways. They used them all to move the legions through Bedfordshire to the heavily fortified line of the Fosse Way in Warwickshire and Lincolnshire - and thence to the new power centres in Chester, Manchester and York.

The building of the waterways network in the 18th century brought the Grand Union Canal to the western edge of the county and added another series of itinerants. The canal survives as a primary leisure facility.

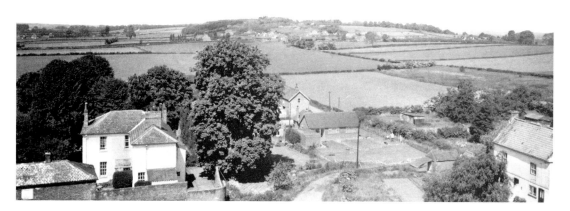

We know those same Roman roads today as the A5, the A6/A600, and the A1; with the modern addition of the M1 motorway, they make 21st-century Bedfordshire little but a transitory memory for the majority of travellers. My father once told me that he considered our native county as the one part of England most easily forgotten by all but those who live there.

This is possibly because of the difficulty in fitting Bedfordshire into the context of a region. It is Anglian in geographical context, but not of East Anglia - and there is no West Anglia. The South Midlands perhaps? We have East and West Midlands, but no claimant closer to the Equator. And yet Bedfordshire has a wealth and diversity of content and social character to enable it to be a major contributor to any regional debate. From the industrial south, dangerously close to being subsumed into the increasingly marginalized 'London and the South East', through to the rurality

above the line drawn by the A418 and A507 roads, it is possible to encounter every aspect of modern life in a manner that does not always jar and clash. The arts mesh with technology. The ancient slides gently into modernity. Local accents move rapidly from semi-Estuary to agricultural with hardly a side-step. It is the county that gave birth to John Bunyan, non-conformist preacher and author of 'Pilgrim's Progress'. John Donne, the poet beloved of lovers everywhere, was rector at Blunham from 1621 until his death in 1631, and William Cowper, the gentle poet, gave apparent vent to his bouts of depression when writing 'Olney Hymns' and 'The Poplar Field' while living at Olney with Mary Unwin. And although H.E. Bates spent the last 40 years of his life in Kent, his character 'Uncle Silas' is easily identified by anyone frequenting the many smaller Bedfordshire country pubs. Bates unfortunately suffered the indignity of being born just over the northern border in Northamptonshire.

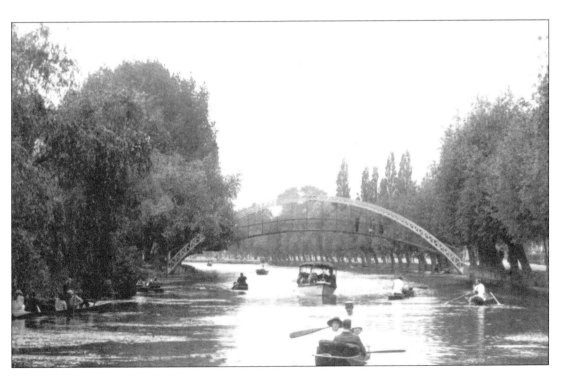

Bedford, The Suspension Bridge 1921 70446

Luton, Dunstable, Houghton Regis and the Surrounding Villages

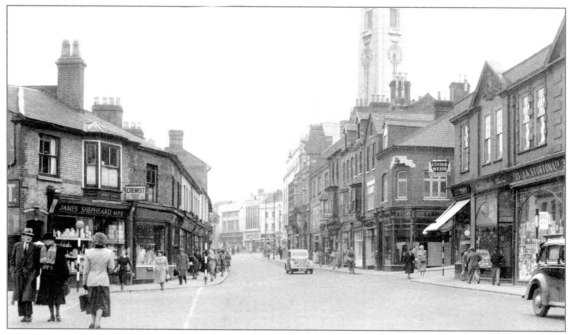

Luton, Manchester Street c1950 L117023

Luton and Dunstable are, for most practical purposes, one town - almost begging to be a city. Until recently, the local economy was heavily centred on the automotive industry - at one time 27,000 people were employed at one international company, and a further 10,000 at another. But as globalisation emerged in the latter quarter of the 20th century, automotive design and production has moved to other countries, and the local business emphasis has shifted to encompass the technology and service industries.

In my grandfather's day Luton in particular was both supplier and consumer to the rest of the county. This apparently ideal state of affairs arose because a number of engineering enterprises built and serviced agricultural machinery used in the production of cereals, which in turn produced quantities of straw suitable for plaiting for use in the hat industry - Luton then was also the centre of excellence for boaters, panamas and even straw police helmets. Hat manufacturing, both straw and blocked felt, and the specialised machinery used in hat production, was a secondary mainstay of the local economy until the early 1950s, when post-World War II ladies' fashions decreed that hats were no longer the mark of feminine gentility and men returning from National Service determined never to wear a hat again. By a

strange coincidence, in the 1970s I moved to a location close to the Cheshire town of Stockport (also a hatters' town), and there found a number of people who had worked in the industry in Luton and moved to the north-west as manufacturers had concentrated production in that area in answer to a shrinking market.

Dunstable has been in existence in one form or another since prehistoric times. Earthworks and burial mounds are to be found on the chalk hills above the modern town; the Romans built a fortified town at the cross-roads of Watling Street and the Icknield Way. Subsequent generations built an economy based on agriculture and straw plait. Any

variations in income from either of these were tempered by the fact that the town was also a coaching stop of some importance.

Houghton Regis owes its regal title to ownership by King Henry I, who eventually gave a large portion of the curtilage to his new Priory at Dunstable and split the rest of the manor between his son and a favoured baron. The division meant that the growth in the area stagnated for hundreds of years until the 18th century, when both sections were purchased by the Brandreth family and reunited under one master. Nowadays Houghton Regis is indistinguishable from its southern and eastern neighbours Dunstable and Luton.

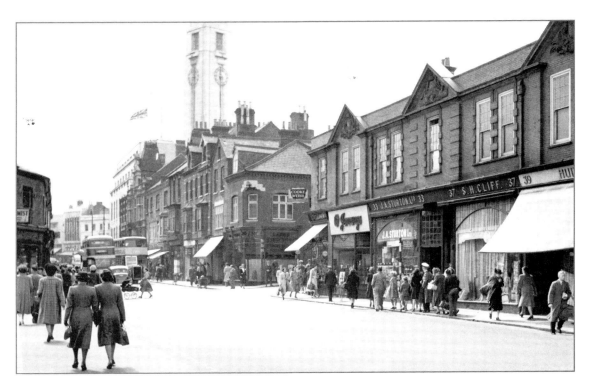

Luton, Manchester Street c1955 L117003
As one of four major thoroughfares leading to the Town Centre, and formerly called Tower Hill, Manchester Street's importance was typified by the presence of many privately-owned shops and businesses and the quality of the buildings they occupied. Bridge Street on the left and Gordon Street on the right-hand side were the boundaries of 'old' Luton, and the architectural changes between the 19th and 20th centuries are clearly visible. There are few changes over the five-year period between these pictures, with the possible exception of increases in traffic flow.

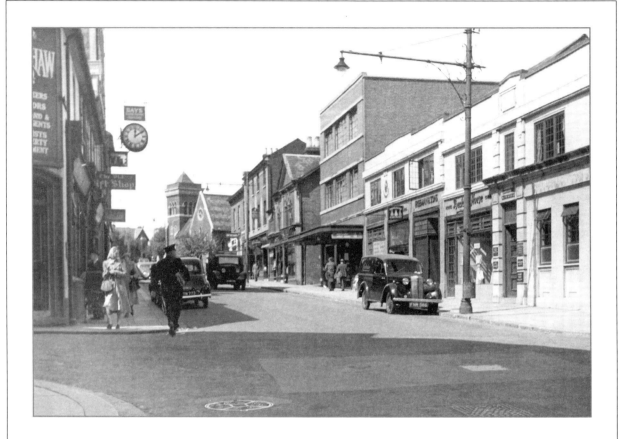

Luton
Upper George Street c1950 L117005
Originally called Dunstable Street, there is no available record of
the reason for the change of name apart from the coincidence of
the accession to the throne of King George V. Certainly there
would have been confusion between the original title and the
burgeoning Dunstable Road just visible in the photograph beyond
Christ Church at the top of the hill. Upper George Street in 1950
was a street of estate agents, small speciality shops, insurance
companies and the Clarence Arms - one of the town's oldest pubs.
Its access value lay in the proximity to the main post office and the
central police station, both of which were in walking distance via
the narrow road on the left.

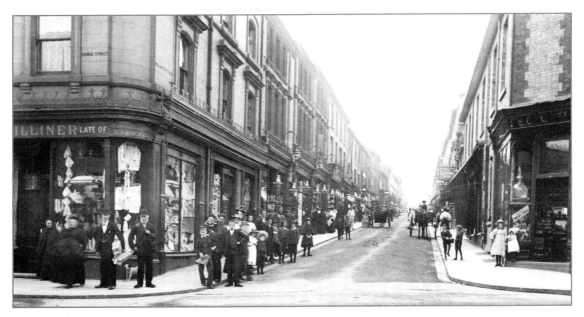

Luton, Wellington Street 1897 39704
Many of the business on Wellington Street were trading until well into the second half of the 20th century. Certainly the pharmacy on the right existed in the 1950s, and the early form of department store sporting external gas lighting on the left of the street was a source of haberdashery and household linens during the same period. Wellington Street was also the site of Luton's first cinema, located in one of the buildings on the crest of the hill; it opened in the early 1900s.

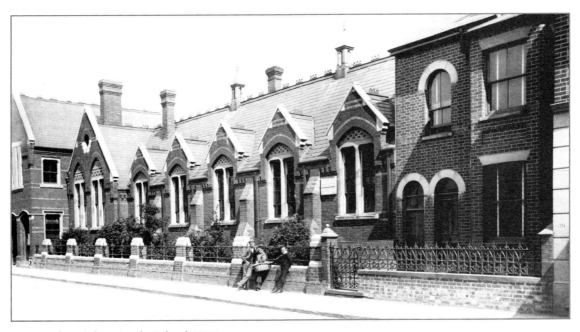

Luton, The Higher Grade School 1897 39724
The forerunner of secondary modern schools and comprehensives, Waller Street School was established during the period when extended education beyond the age of 10 was unusual. Of the three boys in view, possibly only the one on the right is involved with the establishment. The houses on the right existed until the 1960s, but were in use as commercial establishments by that time.

▼ **Luton, The Secondary Technical School c1955** L117080

Luton's dependence on a good supply of fully trained technicians and tradesmen meant that the old Technical School was transferred from Park Square (now the site of Luton University) to this site on the outskirts of the town. Pupils were accepted here from the age of thirteen, by examination, and were given a vocational education to prepare them for apprenticeships with many of the town's engineering companies.

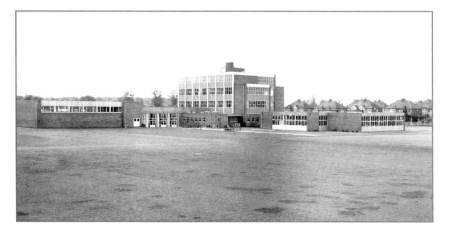

▼ **Luton, The Corn Exchange c1950** L117007

In the immediate post-war era, Luton was a medium sized town - albeit a county borough - about to become very much larger. Few national brands were to be seen on the main street, apart from Lipton's grocery and the Westminster Bank visible in this photograph; the remainder are locally owned and managed businesses. Butting onto the pavement area on the left is the bulk of the Crown Inn, one of two coaching inns at the end of the old road to London. By 1950 the Corn Exchange was no longer in regular use.

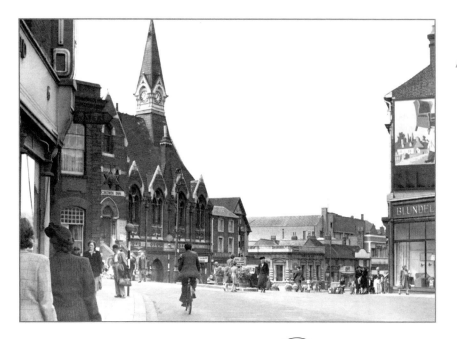

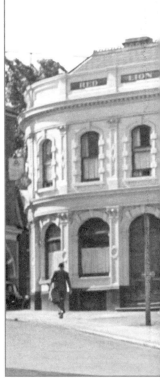

▲ **Luton, Castle Street c1950** L117012

The splendour of the Conservative Club building dominates the 'town' end of Castle Street, although the narrowness of the roadway belies its importance as the main road leading to London. However, the Red Lion hotel owes its existence to its past as a coaching inn - and the street itself derives its title from its very early importance as the road leading to Robert Waudari's castle. Waudari owned Luton as a gift from King Henry VI.

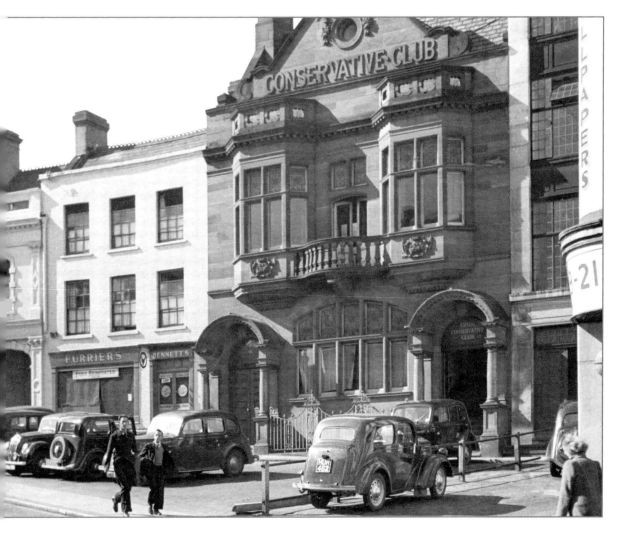

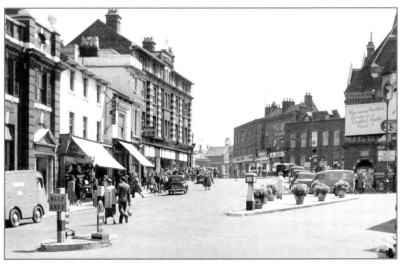

◀ **Luton, Market Hill c1950**

L117006

Once the site of Corn Market House, where weekly markets were held for the sales of corn and straw plait, Market Hill underwent a major refurbishment in the 1860s, culminating in the joint opening of the new Corn Exchange and the nearby Plait Halls in 1869. The outdoor market, held weekly on Market Hill and Park Street, moved into the Plait Halls in 1925 and became a daily occurrence in the process. In this photograph, the side entrance to the market halls can just be seen to the side of the Plough Inn on the left.

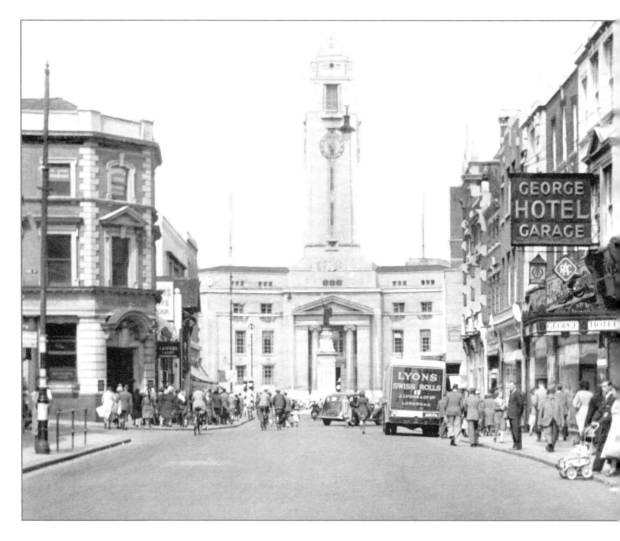

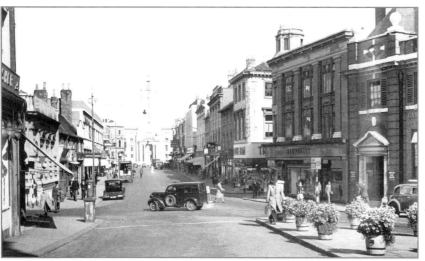

◄ **Luton, George Street c1950** L117011
Street furniture is on the increase, and Luton's planners show innovation for the period with the first example of a mini-roundabout, just visible behind the vehicle in the middle of the photograph. The Button Bros fascia sign on the left marks the location of the official supplier for uniforms and haircuts for the boys from Luton Grammar School.

◄ **Luton, George Street and Town Hall c1950** L117004

▼ **Luton, George Street and Town Hall c1950** L117022

These two photographs were exposed just a few months apart and give a good measure of the speed of change in just a short period. The management of the George Hotel on the right had obviously decided that a face-lift was in order. A coat of paint, a change to the lettering on the canopy and removal of all the protruding signs - and George Street has a fresh image for part of its length. The Lyons van parked in the earlier picture also indicates the location the J Lyons teashop, complete with appropriately dressed waitresses and cups of Horlicks for small children.

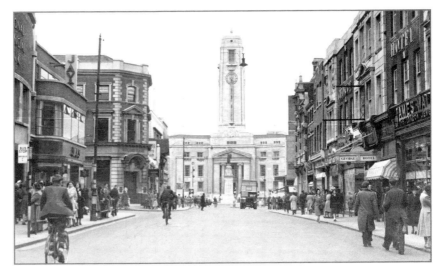

► **Luton, The Town Hall c1965** L117095
Once controlled by a simple set of three traffic lights, the junction of George Street, Wellington Street (left) and Manchester Street (right) now requires a multi-function system complete with laning, bollards and the possibility for total chaos. Rising majestically over it all, Luton's Town Hall has developed 'eyebrows' - a set of semi-permanent offices on the roof of the original building to cope with an ever-increasing multitude of local government officials.

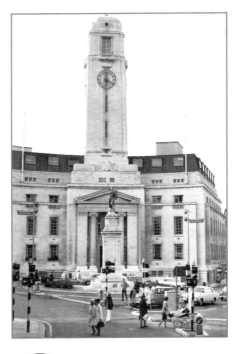

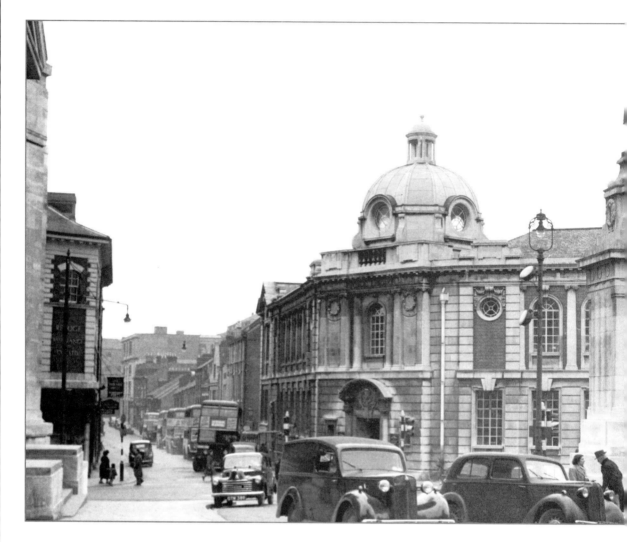

◄ **Luton, George Street 1897**
39699
Viewed from the Corn Exchange on Market Hill, Luton's main street on a summer's day just before the turn of the 19th century gives little indication of the importance of this thoroughfare. The ornate stone monument in the foreground - known locally as The Pepperpot - is the Ames Memorial, dedicated to magistrate and landowner, Lt Col Lionel Ames. Note the 'stop me and buy one' ice-cream cart placed in its shadow. The building at the far end of George Street is the first Town Hall, opened in 1847.

◀ **Luton, The Library and the War Memorial c1950** L117026

▼ **Luton, The War Memorial c1965** L117098

Convenient it may have been, but many Lutonians saw the replacement of the Andrew Carnegie public library building with an example of modern architecture as an act of desecration. The forerunner of modern supermarket shopping next door (J Sainsbury) held its peace. One change with which no one disagreed was the removal of the bus terminus in Williamson Street (opposite) to a dedicated site nearby. In the meantime the War Memorial sprouted flower beds, and the street lighting was upgraded from tungsten lamps to sodium.

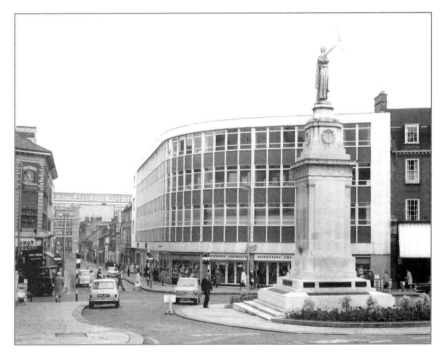

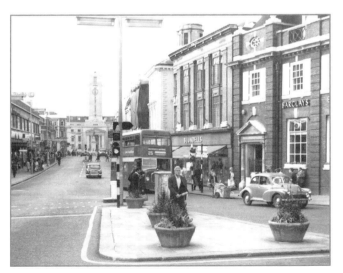

◀ **Luton, George Street c1965** L117096
This view was taken from almost the identical position to the 1897 photograph, and it is surprising to see how many of the previous century's buildings continued to exist with the addition of modern façades. The bus in the middle foreground shows its destination as 'Vauxhall Works', the town's major employer in 1965. The 'new' Town Hall was built to replace the original, which was destroyed by fire during rioting after the Peace Day celebrations in 1919. Family legend has it that grandfather came home with two left boots from the looting that followed the riot. Most of the middle-distance buildings to the right of the picture were demolished in the 1980s as part of a shopping mall development. Blundells, the department store on the immediate right, has existed on more or less the same site since the mid-1800s.

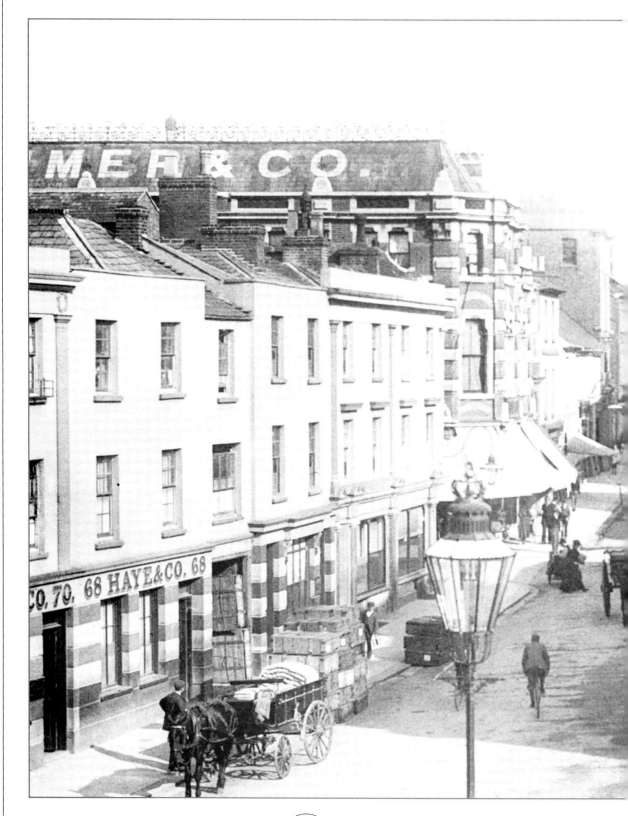

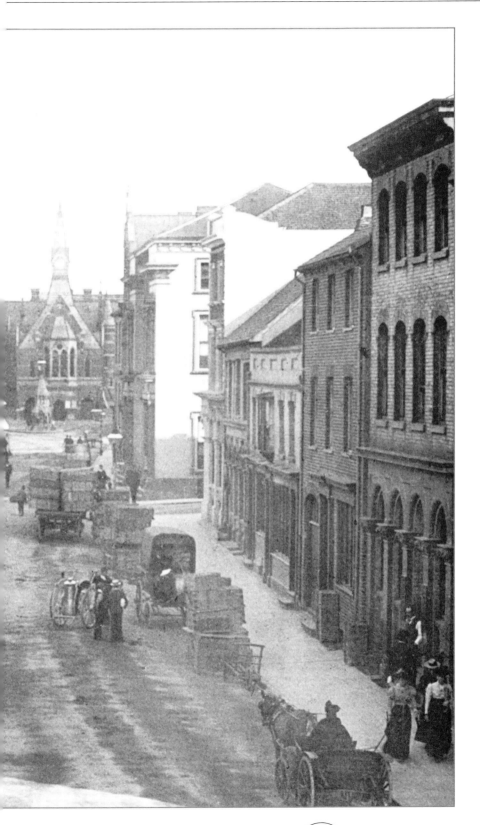

Luton, George Street 1897 39701
Hat manufacturers and accessory wholesalers occupy most of the buildings shown in this reverse view to photograph 39699, page 22. The crates all contain hats, possibly being delivered to the relatively new railway depot for trans-shipment. The Corn Exchange, sitting on Market Hill in the far distance, was opened in 1869 and also served as the Court Leet, public meeting place and concert hall - in addition to its prime function.

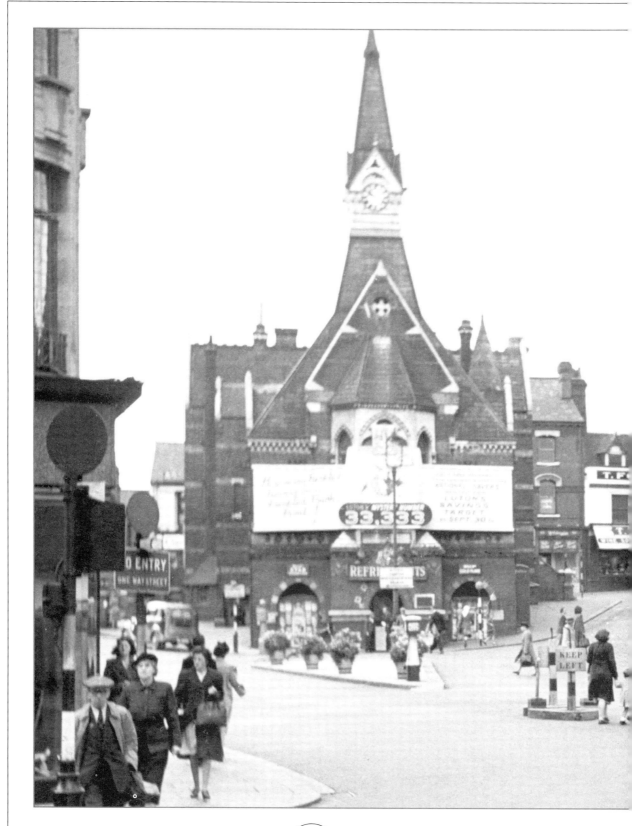

Luton
The Corn Exchange
c1950 L117013
Being originally a market place and meetings venue, the focal point of the Corn Exchange was often used to highlight social campaigns such as the National Savings promotion shown here. The Exchange was demolished in 1951. The shops to the right show physical evidence of Luton's ability to graft 20th-century fronts onto 19th-century buildings.

Luton, Park Square 1897 39703
This open space at the junction of the roads leading to Hitchin, Wheathampstead and London was large enough to support the open-air market, which stretched the 100 yards through the middle of the picture from the Corn Exchange through to Park Street. The shops on the left were originally dwelling houses dating from 1760. Note the wide pavements - an indication of the 'quality' of the area.

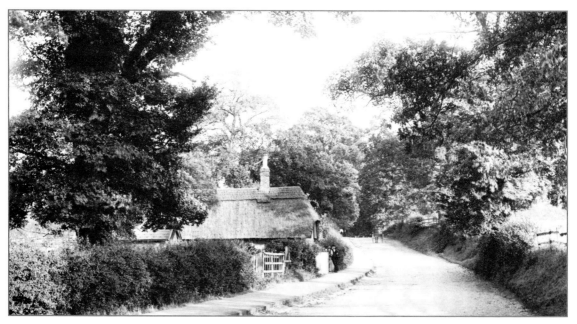

Luton, Park Road 1897 39726
This pleasant scene, just three-quarters of a mile from Park Square, is a good indication of the rural nature of the town and its economy at the time. The thatched cottage, known as 'Why axe ye', was a favourite subject for early photography. Park Road eventually became Park Street, and is now fully developed through to its link with the modern relief roads to the south of Luton.

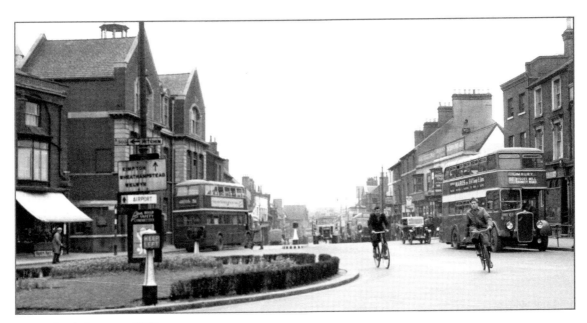

Luton, Park Square c1955 L117024
From market place to bus terminus, centre for further education and declining shopping area; by 1955 Park Square was ripe for the redevelopment that did not actually happen for another 25 years. Partially hidden by street furniture and a Green Line bus, the imposing building to the left is Luton Technical College, opened in 1906 as Luton Secondary School and now the site of Luton University. The pub sign for the Brewer's Tap is just visible to the rear of the bus on the right and just in front of the brewery.

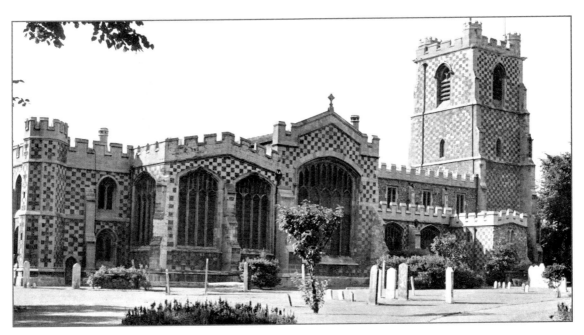

Luton, St Mary's Church c1955 L117009
Built on the site of an early Saxon church, the present St Mary's has elements dating back to the 12th century. Much of the exterior was remodelled in the 15th century to give the striking chequer pattern of flint and stone. The Crown held the living of St Mary's in the 14th century and the fact is commemorated in the baptistery that was presented to the church by Queen Phillippa, wife of Edward III.

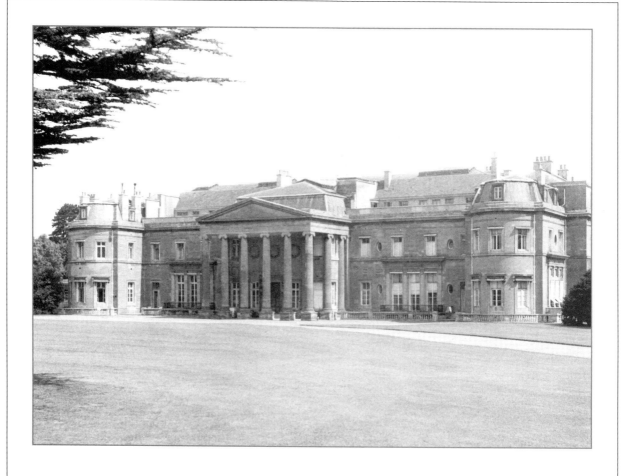

Luton
Luton Hoo c1955 L117071
Originally designed in 1767 by Robert Adam for the 3rd Earl of Bute,
this unique country house was reconstructed in 1843 after a fire in
which little of the original building was left untouched. Subsequently
the Hoo was remodelled in 1903 by the diamond entrepreneur
Sir Julius Wernher, and housed the Wernher art collection until recent
reversals in the family's affairs led to a sale of the property to an
international hotel company. An additional claim to fame is the fact
that the then HRH Princess Elizabeth and HRH The Duke of Edinburgh
spent part of their honeymoon here in 1947.

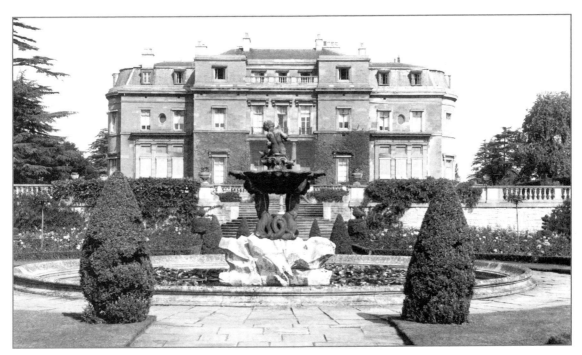

Luton, Luton Hoo c1955 L117055
Much of the Hoo's 1053 acres of parkland were designed and laid out by Capability Brown in the 18th century.
The more formal areas and the rockeries were later additions as part of the refurbishment by the Wernher family.

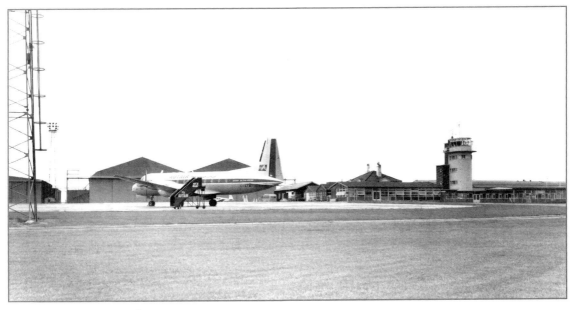

Luton, The Airport c1965 L117102
This is a rare sight, and one unlikely to be repeated: a solitary aircraft on the hard standing at Luton Airport - now
one of the country's busiest holiday departure points. This important facility was opened as a municipal airport in
1938. During World War II it was a base for 264 Squadron, RAF, and also provided a development and
manufacturing base for the Percival Aircraft Company. The photograph shows the 'new' control tower, built in
1952. Air traffic control services have been considerably improved since then.

▼ Stopsley, The Memorial c1955 S381010

The photograph is of the War Memorial to the dead of both World Wars sited on the original Stopsley village green. Growth and proximity to Luton has meant that village has given way to developed suburb. The part that developers have played in the growth of the Luton conurbation is epitomised by the building in the far distance. This was the headquarters of H C Janes Limited, the major developer and builder across the whole of Bedfordshire during the 1950s and 60s. The building to the right of the picture is Stopsley Primary School.

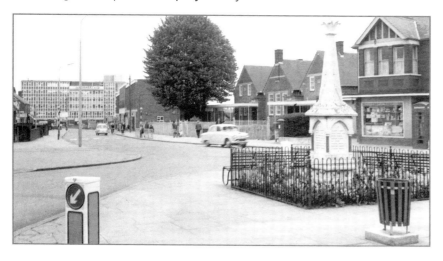

▼ Stopsley, The High School c1965 S381002

Luton developed rapidly in the late 1950s and gathered many of the outlying villages into an expanded borough. Comprehensive 'bigger is better' education styles were adopted with enthusiasm, and Stopsley was one of the first High Schools built to accommodate the new programme.

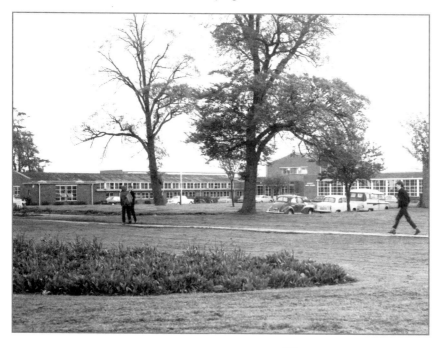

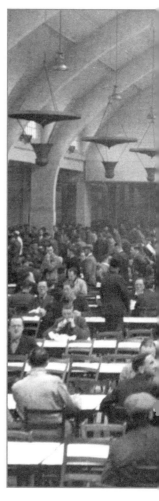

▲ **Luton
The Vauxhall Motors
Company Canteen
c1950** L117034
Part of the main dining room during an average lunch break. This building also housed management dining facilities, the Social Club, and private meeting rooms.

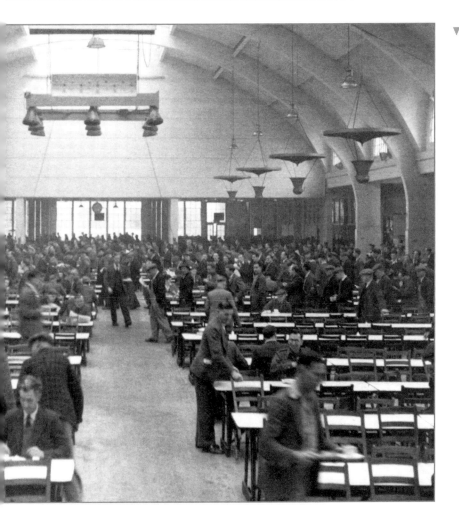

▼ **Luton**
The Vauxhall Motors Factory c1955 L117030
In 1905 The Vauxhall Iron Works moved to Luton from its London base. Thereafter it enjoyed some considerable sporting success and built cars for the wealthy and influential. After World War I, however, the necessity to open its products to a wider clientele imposed financial strains that were only alleviated by the purchase of the company by General Motors in 1925. This impressive building is the company canteen, capable of feeding over half the workforce at any one time. Facilities also included a fully operational theatrical stage and broadcasting equipment that was often used by the BBC for light entertainment productions requiring an appreciative audience. The temporary bollards in the foreground were 'temporary' for five years before being replaced by a more permanent traffic division.

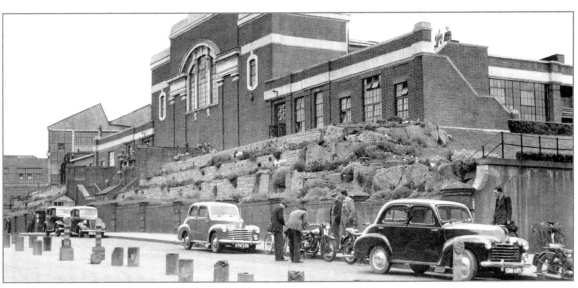

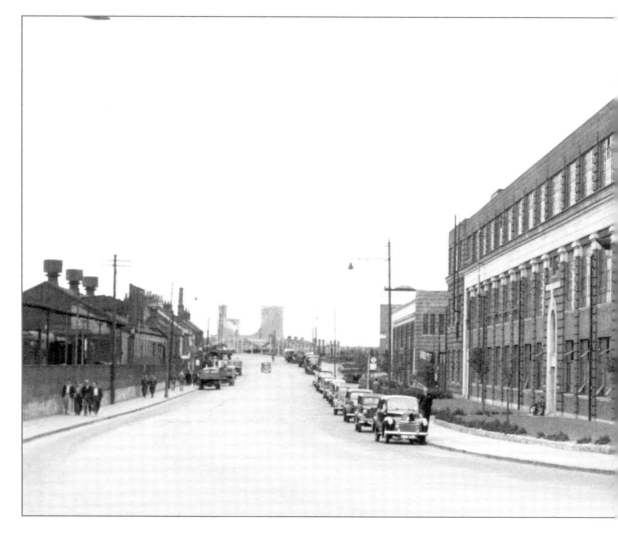

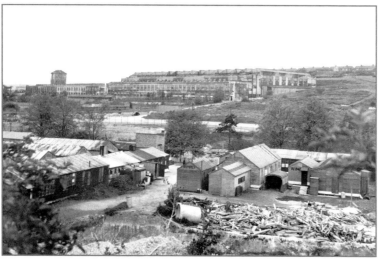

◀ **Luton**
The Vauxhall Motors Factory
c1955 L117027
Such was the scale of operations at Vauxhall Motors that the maintenance and building contractors had their own site (foreground) complete with semi-permanent buildings, security and a fully operational communications system. The rear building on the hill is the famous J Block, the heart of car production and site of the first buildings erected for the company in Luton. H Block, housing the press shop, is the nearer building. Note how wartime camouflage paint is still visible; it remained so until at least the late 1970s.

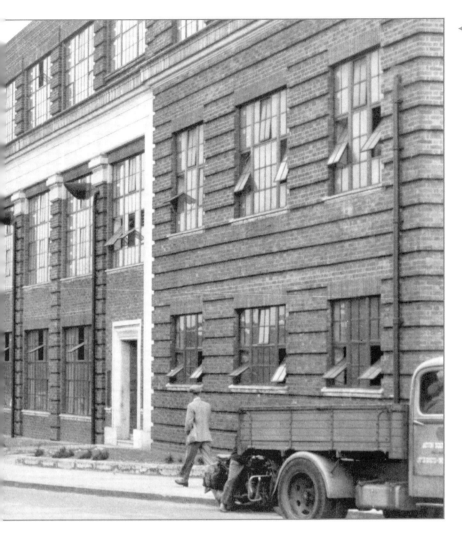

◄ Luton
The Vauxhall Motors Factory, 'P' Block
c1955 L117038
'P' Block was the home of the Production Engineering Department, and was therefore seen by many as the nerve centre for car and van production in Luton. The vents of the old foundry buildings rise on the left, although their original purpose was no longer valid at the time of the photograph.

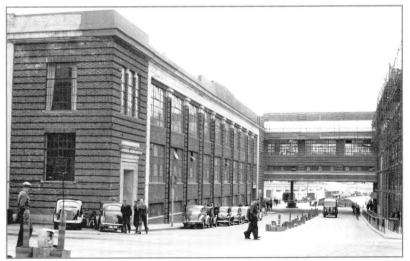

◄ Luton
The Vauxhall Motors Factory
c1955 L117031
The fact that it was possible to park on the side of the road without problem makes this photograph one to be treasured. The building to the left is S Block; it housed the greater part of the marketing and sales functions for the company. Scaffolding on the right indicates that the Bedford van production facility is undergoing an upgrade, and road works immediately beyond the bridge are part of a major expansion of the local infrastructure to accommodate the growing workforce.

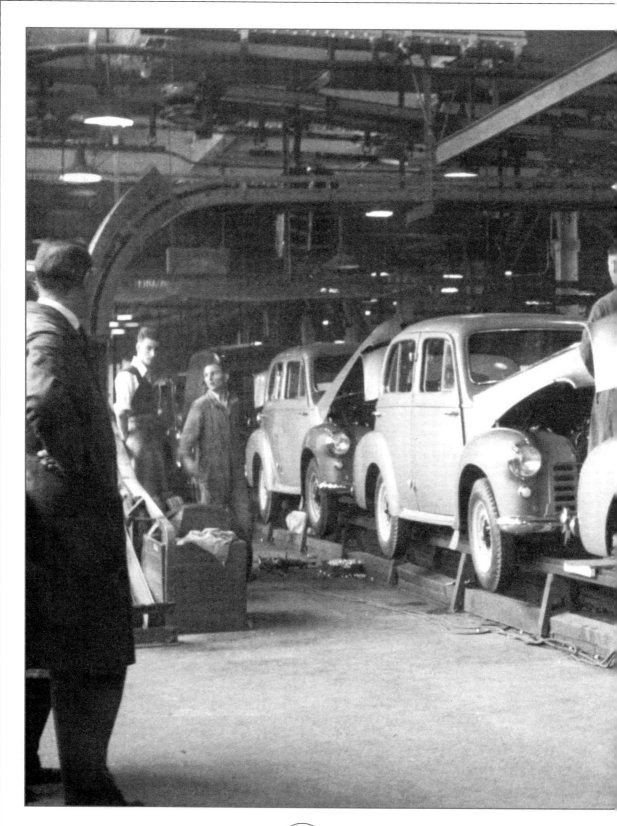

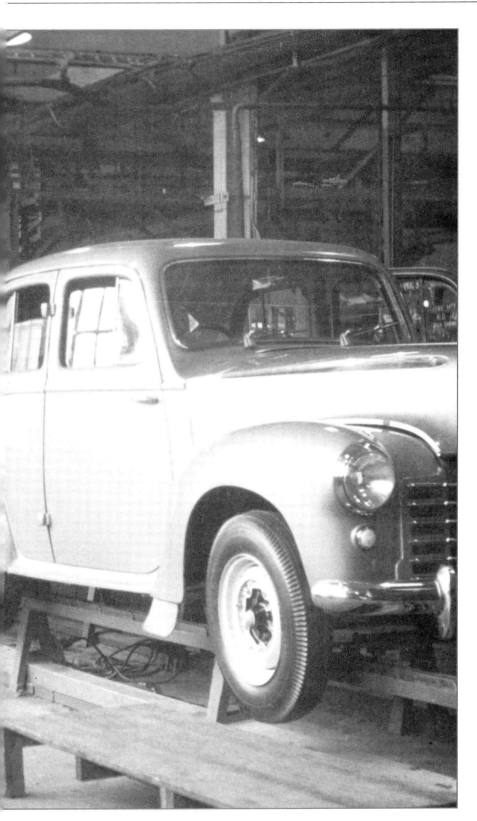

Luton
The Vauxhall Motors Production Line
c1950 L117046
Taken in the famous J Block, sited on the original location of the first Vauxhall production facility in Luton, this photograph shows Vauxhall Wyverns nearing the end of the assembly line. Note the traditional bonnet flutes, a Vauxhall design feature that was transferred to body side panels in the late 1950s and then disappeared forever with subsequent models.

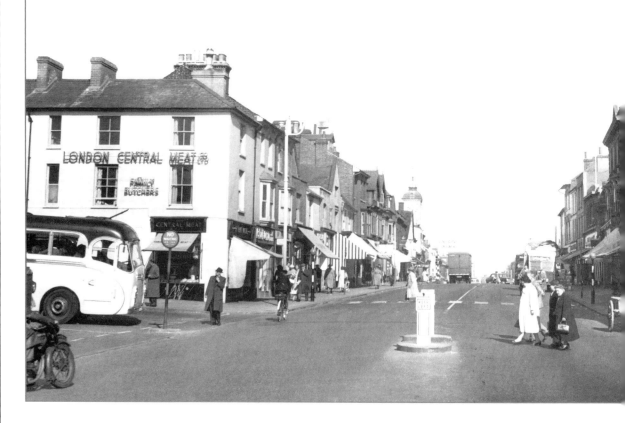

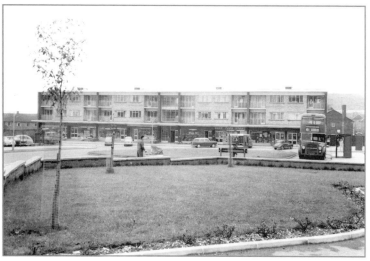

◀ **Dunstable, Downside Estate c1965**
D69046
This photograph (and D69029) show the impact of 1960s development and the architectural mores that governed the town. The Downside Estate was built to cope with a population explosion and increasing affluence. The parade of shops shown here was added to the infrastructure when it became obvious that the existing retail function based on the High Street could not cope with demand and was too far away from the housing. There are signs in the picture of increases in car ownership. The route number 6 bus was owned by Luton Corporation Transport and ran from the Estate through to Luton Town Centre via Houghton Regis.

◄ **Dunstable, High Street South c1955**

D69020

Forming a boundary with the original Augustinian priory site established by Henry I, the High Street follows the route of the Watling Street ancient trackway. The hint of an open space to the left indicates the existence of the market square (and occasional bus terminus). Many of the shops on the right incorporate the word 'Priory' into their titles to indicate their proximity to the Priory Church of St Peter. It was from here that Henry VIII's legal team announced the annulment of the Royal marriage to Katherine of Aragon in 1533.

▼ **Dunstable, High Street North c1955** D69005

The reverse view from D69020, looking south towards the ancient cross-roads of Watling Street and the Icknield Way. The prominent clock tower is Dunstable's old Town Hall, superseded in 1974 when the Borough of Dunstable was incorporated into the South Bedfordshire District Council. On the left is the Sugarloaf Hotel, its sign recalling the town's heyday as a coaching centre.

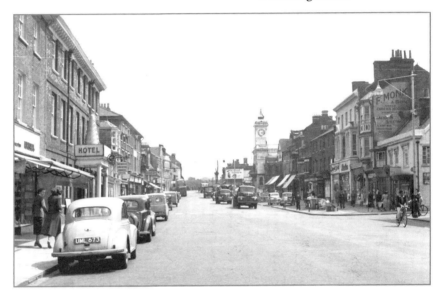

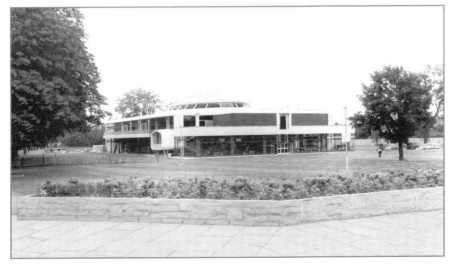

◄ **Dunstable The Civic Hall c1965**

D69029

Dunstable's Civic Hall was built during the same period to much more pleasing dimensions and structural lines as an indication of civic pride in the Borough. However, the facility suffered from being under-used and in 2000 the site was sold to a major supermarket group.

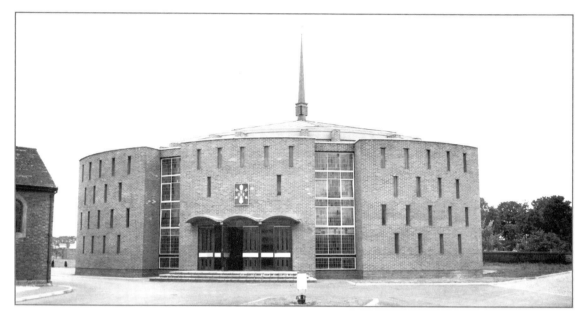

Dunstable, St Mary's Church c1965 D69033
A directory of 1898 noted that in Dunstable 'the Catholics have a mission at 78 High Street'. By 1935 the faith had progressed to the first St Mary's on its West Street site, and on 15 March, 1964, this building was opened with a celebratory Mass.

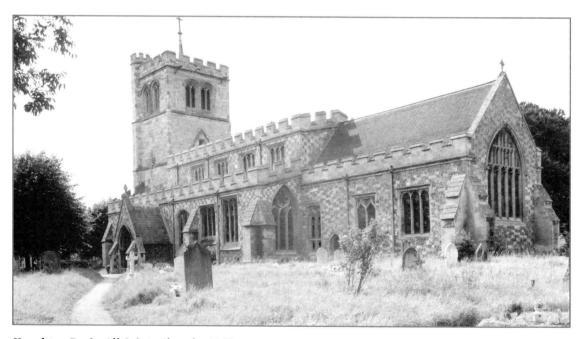

Houghton Regis, All Saints Church c1955 H263011
Kelly's Directory for 1898 lists the Parish Church as 'the church of St Michael, formerly All Saints, ...' so it is obvious that an incumbent and the Church council during the intervening period decided that a return to the safety of multi-sainthood was preferable. Although the parish register dates from 1538, the style, decoration and monumental devices within the church indicate a much earlier presence - at least in the 14th century, since there are brasses commemorating the Waleys family as incumbents from 1400.

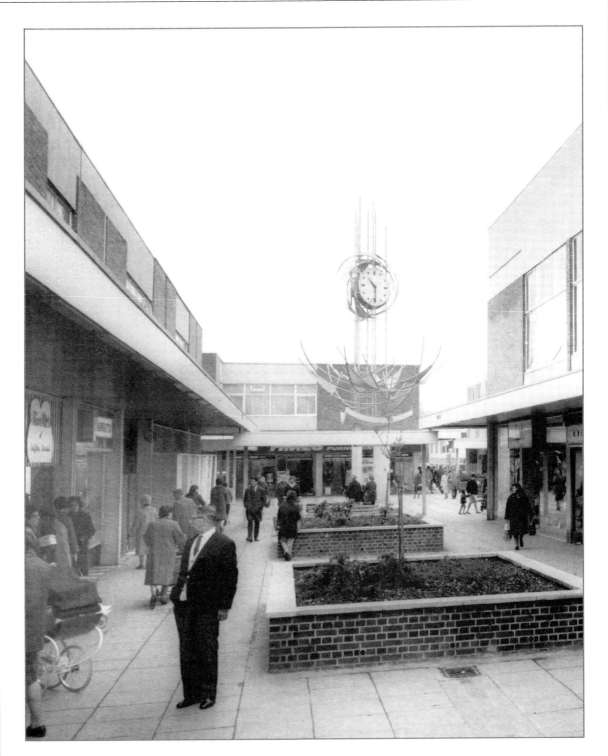

Dunstable, Broad Walk c1965 D69055
It must be assumed that the symbolism of the clock design meant something to the developers of this pedestrianised shopping area, but there is nothing on record to tell us what it might be. The architecture echoes the sterile utilitarianism of the period and must have turned the shopping experience into a joyless affair.

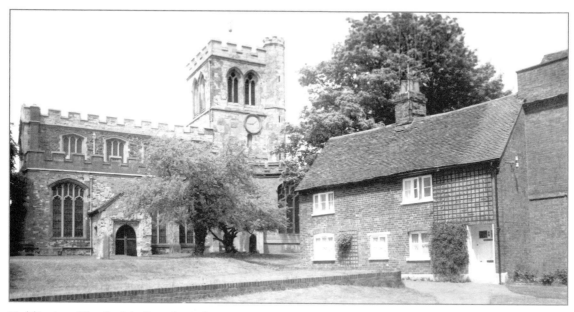

Toddington, The Parish Church c1965 T160032
Dedicated to St George of England (note the full title), the parish church at Toddington is so similar to its counterpart in Houghton Regis, just a few miles away, that it should be suggested that only the same masons could have built it. There is a low mound beside the church that houses the remains of Toddington Castle. Local legend says that a witch is imprisoned within the mound and that you can hear her cooking pancakes if you put your ear to the ground on Easter Day.

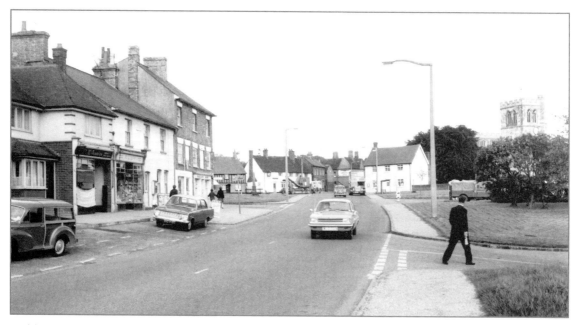

Toddington, High Street c1965 T160004
Village green, church and public house are all in close proximity, but the village atmosphere in Toddington was already under threat at the time of this photograph. The one-time manor is sited very close to the M1 motorway, and the whole area has undergone considerable development because of the demand for housing within reach of London. Affluence has crept into the photograph; both the Vauxhall cars shown carry late registration plates.

Toddington, The Green c1965 T160020
An unusually quiet picture is presented by Toddington's village green. The proximity of a motorway junction, and a service station close to that, has removed any residual tranquillity in recent years. For the nostalgic, however, this image is one to treasure. Georgian houses, thatched roofs, the war memorial and a village pub make a pleasurable combination.

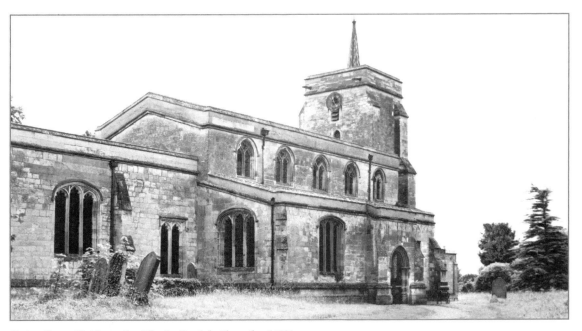

Eaton Bray, St Mary the Virgin Parish Church c1955 E104009
A 13th-century building with 15th-century additions and some 1890s restoration, St Mary the Virgin has some very fine ironwork from the original building still in operation on the south door. These are attributed to an ironworker from the county, one Thomas of Leighton, who also made the grille for Queen Eleanor's tomb in Westminster Abbey.

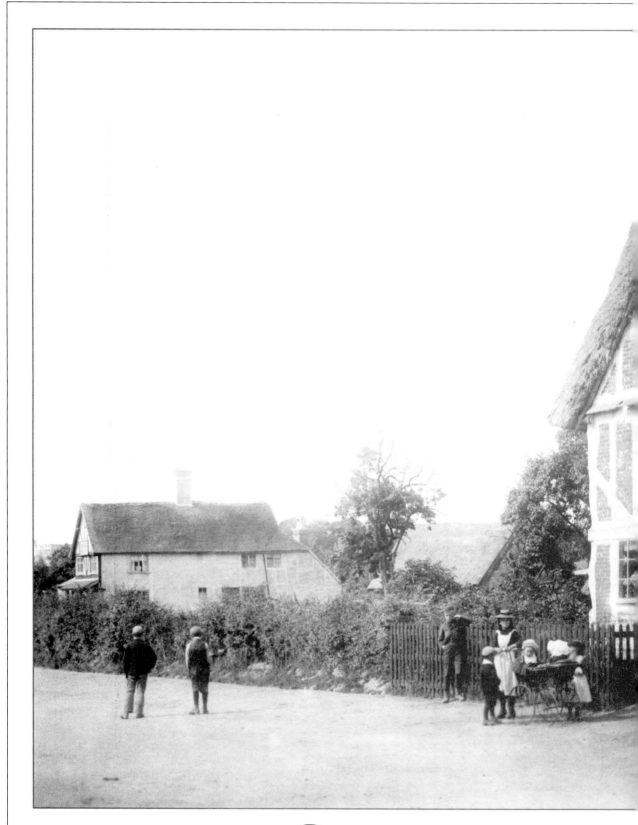

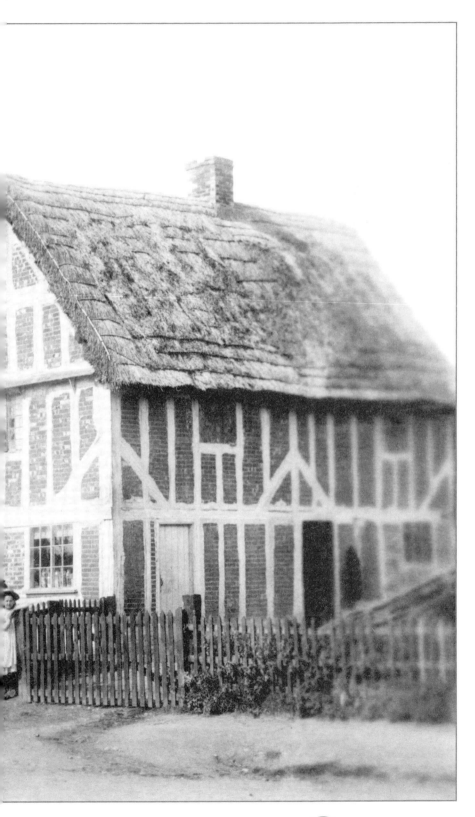

Totternhoe
The Village 1897
39754
This pretty scene with
its unmetalled road and
air of tranquillity could
almost prevail in
modern Totternhoe.
Certainly many of the
current properties in
the village are thatched
and show the form of
construction used on
the house in the
foreground. Totternhoe
Knolls is the name
given to the remains of
Totternhoe Castle, a
motte and bailey over
Saxon remains, of
which only the
groundworks remain.
The area is designated a
Site of Special Scientific
Interest and a
Scheduled Ancient
Monument.

Leighton Buzzard, Woburn, Aspley Guise & Steppingley

Despite having diverse characters and a beautiful simplicity in style, the villages and towns in the west of Bedfordshire have lost much to the encroaching development by their economically stronger neighbour, Milton Keynes. Fortunately, individuals and local special interest societies have also preserved a great deal, keeping the worst depredations at bay. Main access roads have been routed away from village centres and the design character of the new housing stock has been forced into conformity with the best elements of the existing homes - many of which date back to the 18th century.

Leighton Buzzard's name has nothing directly to do with birds of prey, despite several local organisations adopting the title 'The Buzzards' and using the hawk as an emblem. Leighton is corruption of the Old English for a leek (or vegetable) farm, and Buzzard is an extension of the family name of Theobald de Busar, the first

Leighton Buzzard, The Cross c1955 L211008

prebendary for the area. It is a traditional market town that has managed to retain its unique history and character while meeting the demands of a busy area in the 21st century. A network of streets and narrow shopping mews funnel into Market Square, where the 19th-century Town Hall and a fine 15th-century market cross are located. From here the broad High Street, with many interesting buildings, leads to Church Square and the 13th-century All Saints Church. The High Street also supports a busy market on Tuesdays and Saturdays. A busy visitor attraction is the Leighton Buzzard Railway. Based on an early 20th-century private line used to haul sand, the 6-mile round trip takes the traveller from Page's Park out to Stonehenge Works and back.

Woburn is a smaller market town than Leighton Buzzard but given equal prominence by its association with nearby Woburn Abbey, the seat of the Russell family (the Dukes of Bedford) since 1574. Early Woburn suffered by fire in 1505, and again in 1724, but was entirely rebuilt on both occasions. The second time it was rebuilt with the benevolent assistance of the Duke, which is reflected in the open aspect of its current layout and the quality of the older façades on the main road through the village.

Aspley Guise has also benefited over the centuries from one family's involvement with the town - in this case the Moore family, headed by the 18th-century rector of St Botolph's parish church, the Rev John Vaux Moore. Successful landowners as well as clerics, the Moores lived in the manor house fronting onto the village square. Built in 1786, it is currently an hotel. Incidentally, the 'Guise' part of the village title refers to earlier ownership by the Guise family - also commemorated by a section of armour dating from the 15th century and stored in the church.

Steppingley was for many years one of the prettiest villages in the county, and can still hold its head high in this context. It has two claims to fame. The first is the quality of the food and ales at the local hostelry, the French Horn, which have secured adherents from around the world. The second is the fact that Steppingley was, for 50 years in the 16th century, owned by New College, Oxford. It is not recorded why the College gave up its potentially lucrative holding.

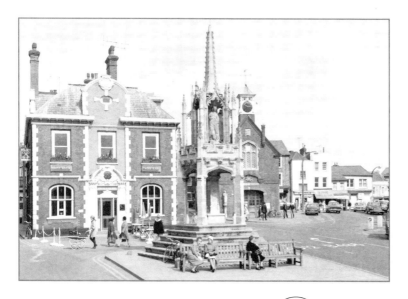

Leighton Buzzard, The Cross c1965 L211077
Given a decade of fresh ideas (see L211008 on the previous pages), the area around Leighton Buzzard's 15th-century Market Cross is once again a focal point and meeting place. A bus stop is resited; the Cross Keys is given a face-lift by the brewery; the area around the Cross is paved, and seats are added for the benefit of those taking a rest from shopping. With two neighbouring properties up for sale, the family butcher in the right background is possibly finding itself under development pressure.

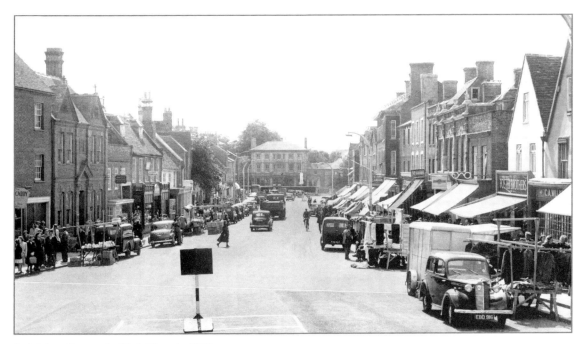

Leighton Buzzard, High Street c1955 L211028
A large number of the buildings in this photograph are now Grade II listed, but the dishevelled look of the market stalls did little to foster civic pride in antiquity. At the time of writing, the High Street has been partially pedestrianised and by-passed as a main thoroughfare for traffic.

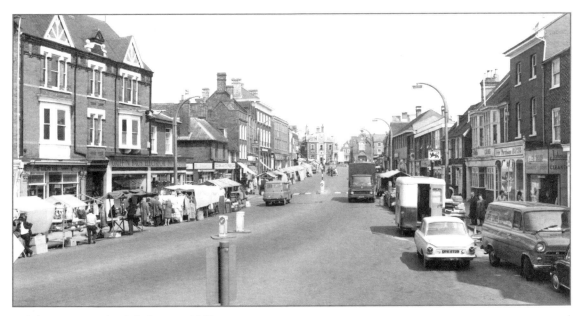

Leighton Buzzard, High Street c1965 L211072
The funnel effect of the town's main street in 1965 can be fully appreciated in this photograph. The Black Lion public house on the right was originally on the opposite side of the road. In 1793, the site that now carries the name was known as the Sow and Pigs. In 1800 it became private housing, and it was another 90 years before the building was returned to the inn trade as the Black Lion. An entrance at the side of the building leads to the original stable yard.

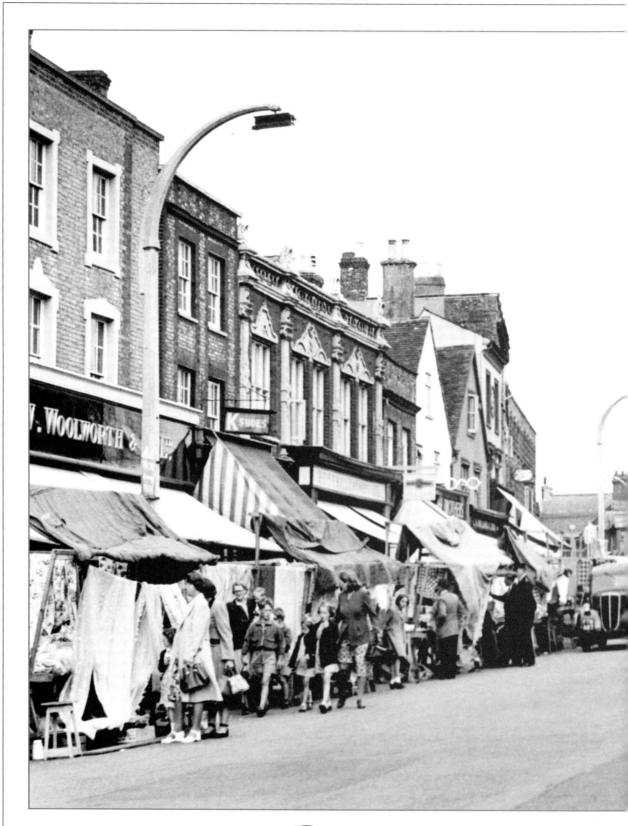

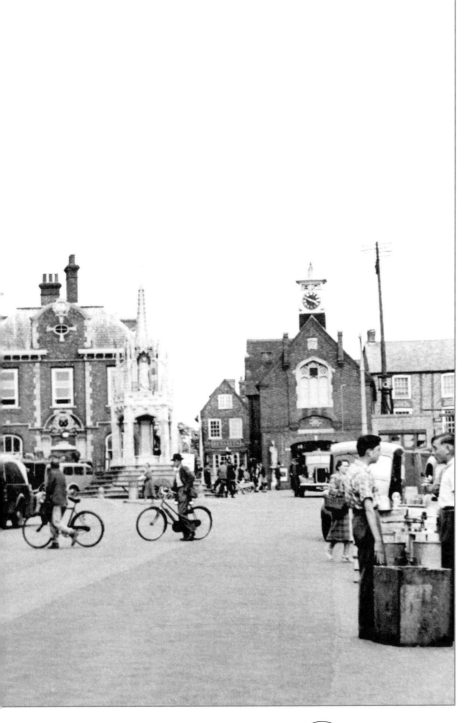

**Leighton Buzzard
Market Day c1955**
L211031
A haphazard collection
of stalls and covers
which today's local
government would not
tolerate. Woolworth's
displays its original
American house style
above the shop front,
and the chemist two
doors away has yet to
feel the effects of the
corporate marketing
soon to alter the town's
purchasing habits. The
little boy walking with
his mother and sisters
in the left foreground is
wearing the young
man's fashion of the
day - a lumber jacket.

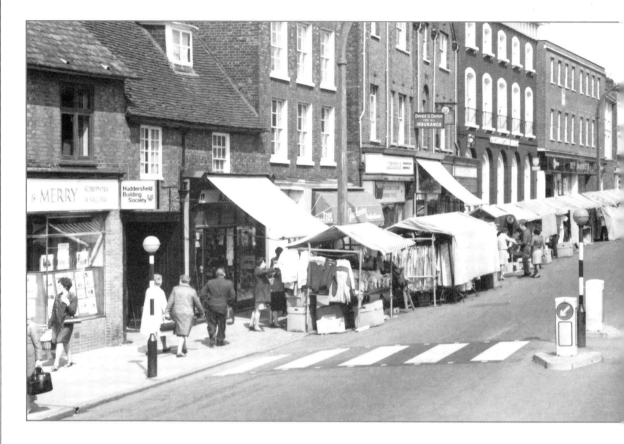

Leighton Buzzard ▶
**High Street and the Market
Cross c1965** L211067
This photograph of the 15th-
century Market Cross shows just
how far the original concept of a
market town has moved in the
20th century. Undoubtedly this
clear space would have been
filled with animal pens and
farmers' stalls only 100 years
earlier. Now it provides a
comfortable resting place after
the trek along the High Street.
The old fire station on the right
was once the Town Hall, which
had a cloistered market area
underneath it. The statue to the
left of the doors is probably one
of a substitute set made for the
Market Cross and subsequently
discarded.

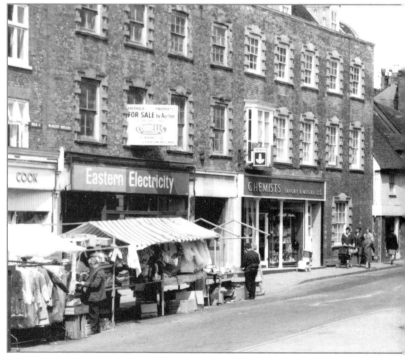

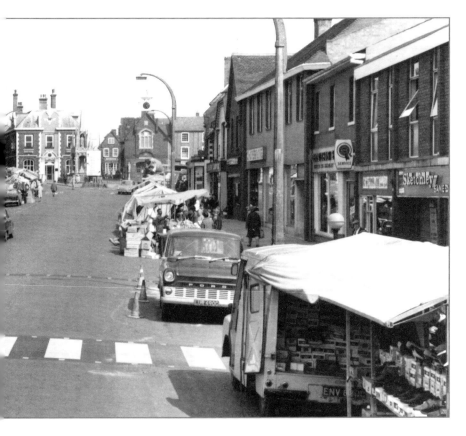

◄ Leighton Buzzard High Street c1965

L211071

Ten years has made a tremendous difference in the appearance of both street and market day. The stalls are more tidy and professional in the goods on display. There is a new zebra crossing to assist pedestrians in the face of a growth in traffic - although this midday photograph suggests the growth is rather limited here. Shop fronts and building façades have been improved. Many have been refurbished and freshly painted. F W Woolworth has given way to Keymarket - an early supermarket chain.

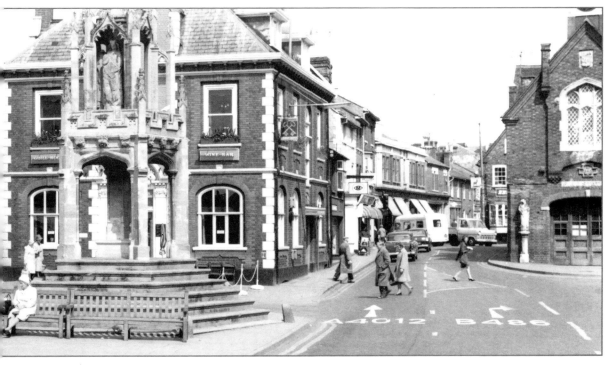

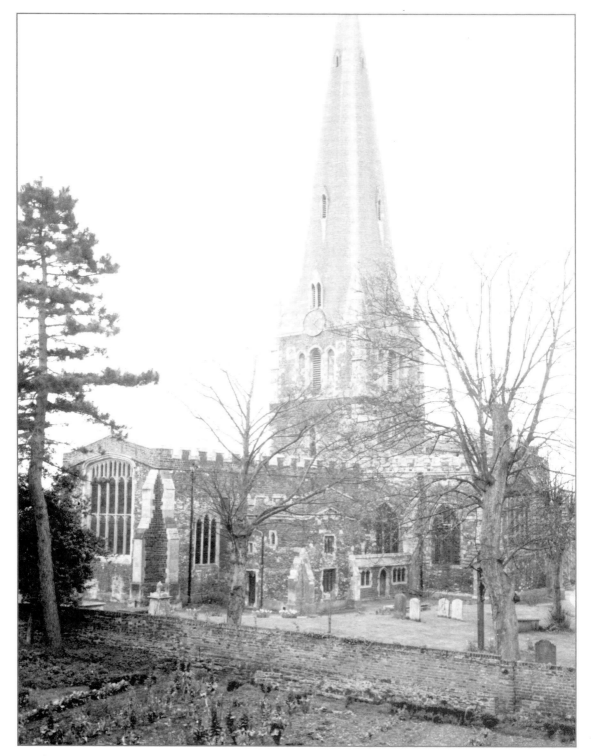

Leighton Buzzard, All Saints Church c1965 L211083
The 190-foot spire of the parish church dominates the roofline on all approaches to the town. This is the second
ecclesiastical building to stand on this site. The architecture suggests a 13th-century influence.

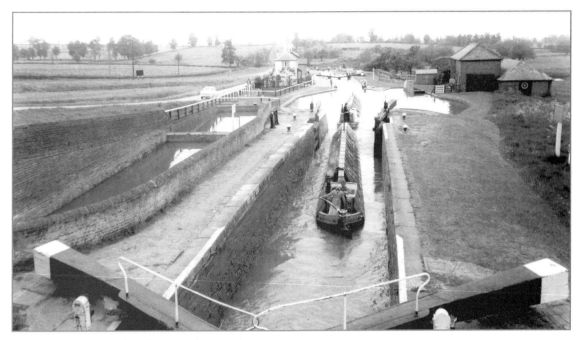

Leighton Buzzard, The Three Locks c1955 L211057

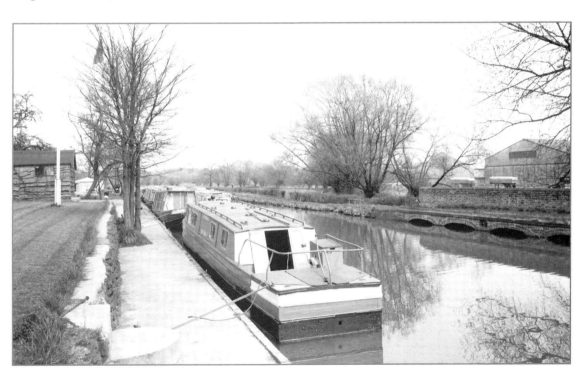

Leighton Buzzard, The Grand Union Canal c1965 L211087
These two photographs illustrate the fundamental change in use for Britain's canal system during the 1950s and 60s. The earlier picture shows working boats doubled up carrying cargo from the London Basin to the Midlands. Ten years later, and the narrow boats are refitted for the holiday market and modified so as to be much easier to handle.

**Leighton Buzzard
The Grand Union
Canal c1955** L211049

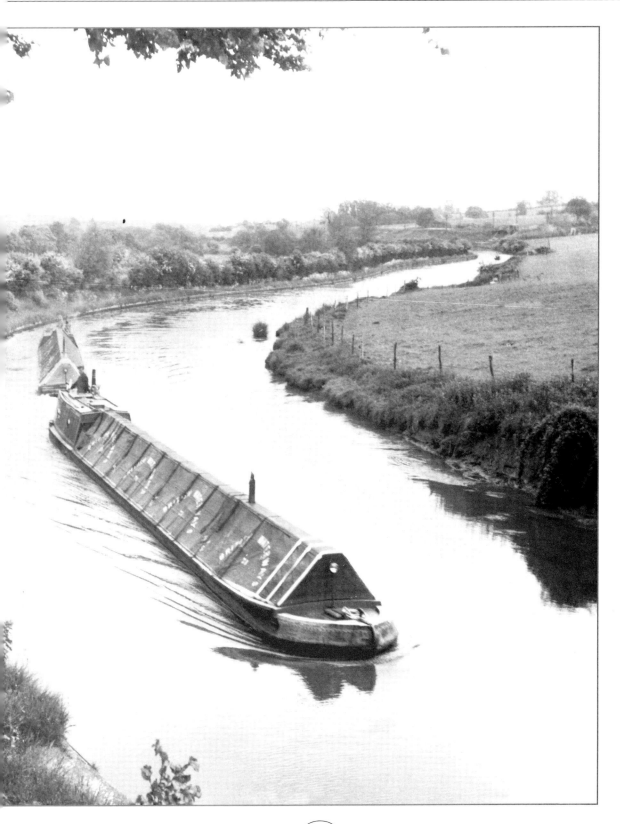

▼ Leighton Buzzard, The Globe Inn and Canal c1965 L211080

The Grand Union Canal (more properly called the Grand Junction) was intended to be the central artery of a web of smaller canals linking London with Birmingham, the Potteries and the East Midlands. An Act of Parliament of 1793 authorised the building of the route at an estimated cost of £600,000, but it was 1805 before it was finally and fully opened with the completion of the Blisworth Tunnel. Travellers planning a full trip today should allow at least seven days to complete the 135 miles and 160 locks.

▼ Leighton Buzzard, The Grand Union Canal and the Globe Inn c1965
L211090

There has been a hostelry on this site for many centuries, but this version was originally built to cater for the navigators who built the canal. Later it welcomed the hard men and women who plied their trade on the waters. Now its clientele are weekenders, fishermen and passing motorists. There is some evidence of conservation activity in the new saplings planted in the foreground of the photograph.

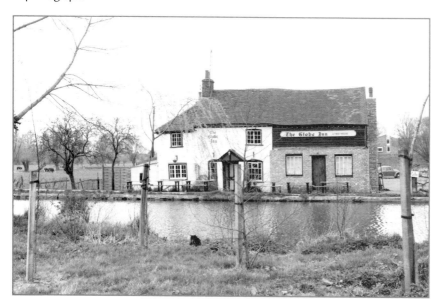

▲ **Leighton Buzzard
The Three Locks c1955**
L211054

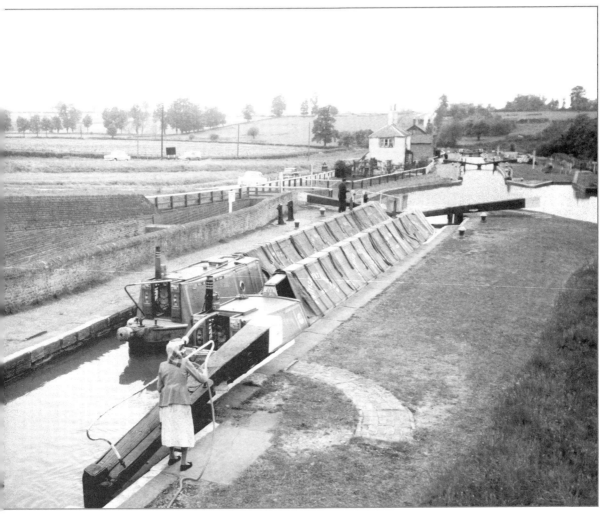

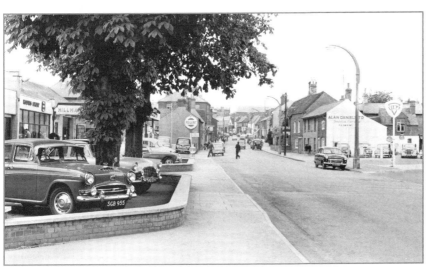

◄ **Leighton Buzzard**
Lake Street c1955 L211061
This broad road leading into the heart of the town is bounded by 17th- and 18th-century buildings. Of more recent times, but not to be credited with the same level of survival, are the brand names visible in the photograph; Regent and Fina petrol and oils have long been subsumed into larger conglomerates, and the Hillman car company has had a chequered history since 1955.

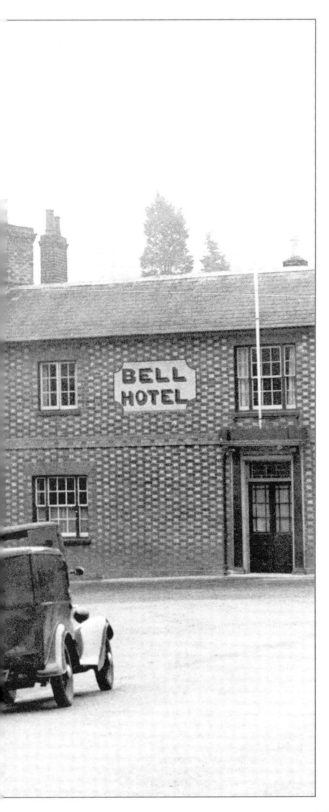

▲ **Aspley Guise, The Square c1955** A161013

◀ **Aspley Guise, The Square c1955** A161016

These opposing views of the town centre illustrate the character and quality of life in Aspley Guise. The grocer's store is part of a small chain that catered for the 'discerning' customer, and the personal nature of the other stores indicates that the owners are committed to a high level of involvement in local affairs. The checkerboard finish on many of the buildings fronting the square is traditional and, in this case, dates back to the 18th century. The Bell Hotel has undergone major refurbishment since 1955, and now sports new windows on either side of the main entrance and a brighter aspect overall.

◀ **Steppingley
The Village c1955**
S380002
The parish church of St
Lawrence dominates this
delightfully bucolic
picture. The direction
sign points to the county
town, 10 miles away,
and there is the classic
confection of village life -
church, public house
with a wall against which
to lean your bicycle, and
the bus stop - all in
perfect juxtaposition.

Aspley Guise
Old Houses c1955
A161007
These 18th-century properties are undoubtedly some that were part of the benefit bestowed by the Moore family in Aspley. The style on the left suggests that it dates from somewhat earlier - perhaps as far back as the previous century.

Aspley Guise
Aspley House c1955
A161003
Built to an original design by Sir Christopher Wren, it is believed that Aspley House's chequered history includes a spell as an outpost of the work of the Special Operations Executive during World War II.

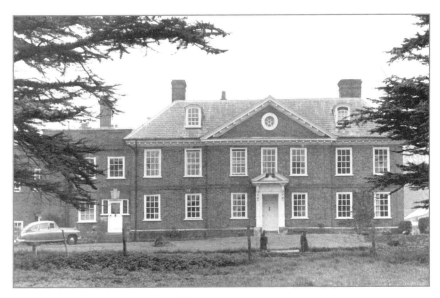

Woburn, High Street
1952 W300002
Now one of the busiest road junctions in the rural region, in 1952 the centre of Woburn was a study in tranquillity. The three-storied and broad-fronted architecture in this section of the village indicates a predominance of wealth and large families among the original owners, following the rebuilding after the fire of 1724.

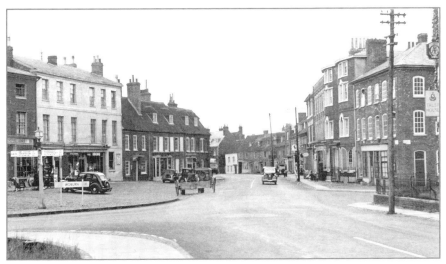

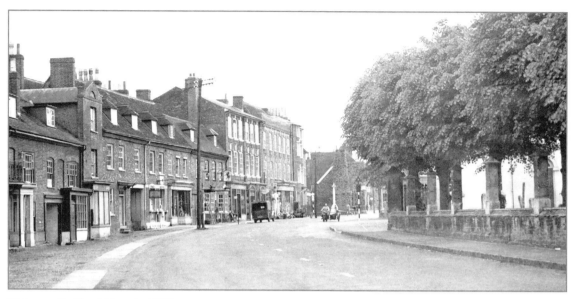

Woburn, Bedford Street c1955 W300006
The date of this photograph is the year in which the Duke of Bedford opened Woburn Abbey to visitors in the commercial sense. There is little in the picture to indicate that the town was about to enter an era of prosperity as a 'honey pot'. As examples, consider the size of the Post Office and the branch of Lloyd's Bank on the left of Bedford Street. It is doubtful if either could cope with the demands of modern visitor throughput. The houses all bear the signs of the Russell family's patronage following the fire of 1724. Cobbled pavements and wide roads are legacies of the period.

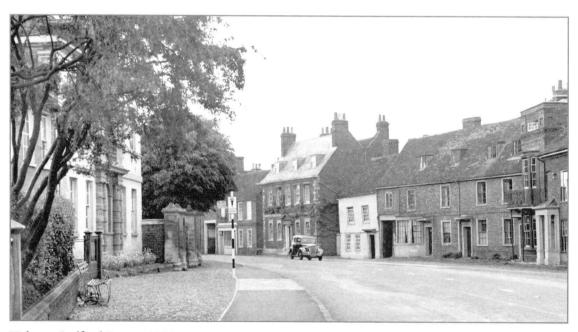

Woburn, Bedford Street c1955 W300004
The reverse view from picture W300006. Note the traditional checkerboard brickwork on the cottages to the right, which also appear to have been the subject of some infill building since the 18th century. The school sign, of the original British pattern, probably indicates the proximity of the school originally established by Francis, the 5th Earl of Bedford.

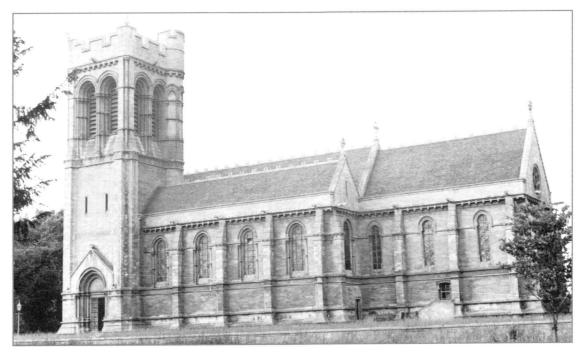

Woburn, St Mary's Parish Church c1955 W300009
Consecrated in 1868, the parish church was funded entirely by William, the 8th Duke of Bedford, at a cost of
£35,000. The architect was a Mr Clutton, who designed the building in the Continental Gothic style.

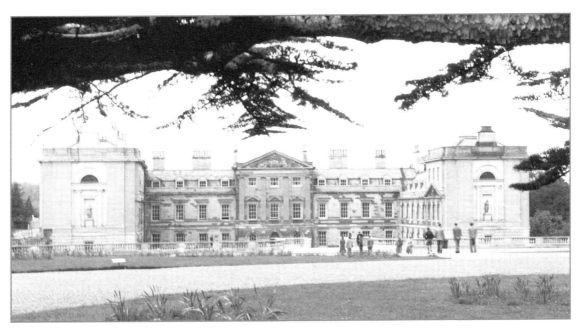

Woburn Abbey, From the Cedars c1955 W301033
The Abbey was originally a Cistercian community established in 1145. Reverting to the Crown after the Dissolution,
the land was largely dormant until King Edward VI granted it to the Russell family in 1574. The house was largely
rebuilt in the 18th century; there have been several additions made since, including much of the infill on the
elevation shown here.

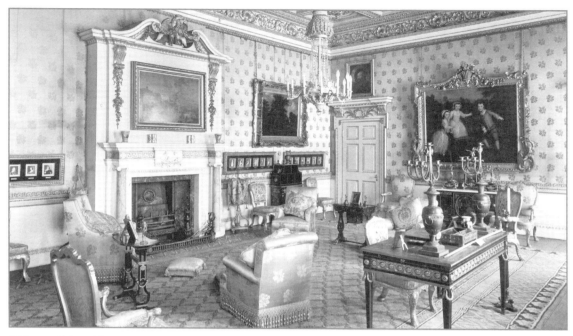

Woburn Abbey, The Queen's Sitting Room c1955 W301307

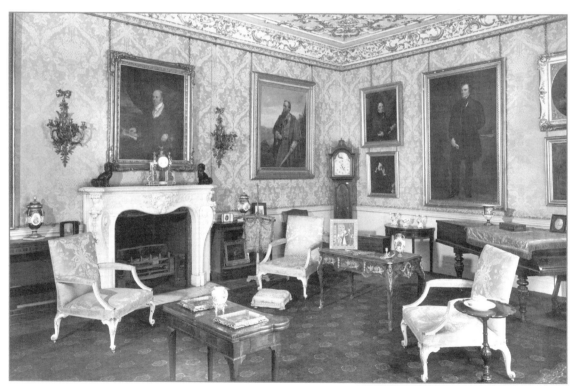

Woburn Abbey, Prince Albert's Sitting Room c1955 W301306
Queen Victoria and Prince Albert visited Woburn on a number of occasions, although it is not suggested that the sitting rooms on view fully reflect the ornate taste in decor of the period.

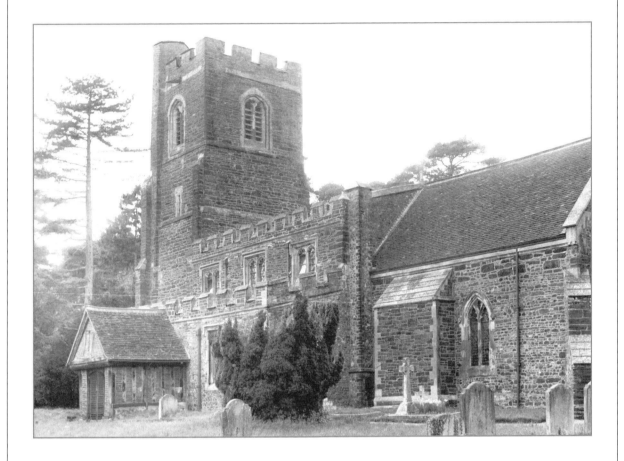

Flitwick
The Church c1955 F108005
Flitwick is a village that has been the subject of substantial
population growth during the 1980s and 90s, tripling its physical
coverage with ease. The parish church of St Peter and St Paul has a
12th-century base, which was subject to the chancel being
widened in the 13th century, and the bell tower being added in the
14th century.

Ampthill

The first settlement in this central valley was 'Aemethyll' in Old English, which translates to 'ant-heap' or 'ant-infested hill'. As one who has camped in Ampthill Park, the writer can vouch for the accuracy of the name. King Henry III made a charter to the town in 1242 confirming the right to hold a market on Thursdays, which prevails into the 21st century, although the site has moved from the Market Place to the car park of a local supermarket.

King Henry VIII and his court paid many visits to Ampthill Castle, including a final journey in which he brought his first wife, Katherine of Aragon, to Ampthill for the last years of their married life. The marriage was annulled in 1533 and Katherine was proclaimed Princess Dowager. The Castle no longer exists, but Katherine's Cross stands in Ampthill Park as a memorial to the tragic event.

The present house in the park was built in 1686-88 for the Dowager Countess of Ailesbury and Elgin. After a chequered intervening 300 years, the house is now a Cheshire Home for the disabled.

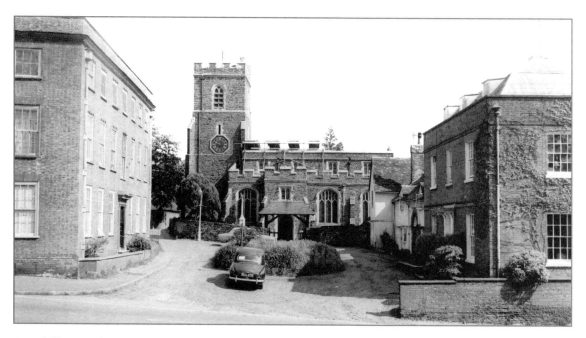

Ampthill, St Andrew's Parish Church c1955 A158073
Most sources quote Ampthill's parish church as 10th century, without offering a precise dating. All, however, make a point of listing a marble memorial to the life of Col Richard Nicolls who captured the Dutch Colonial city of New Amsterdam on behalf of the English Crown - and then renamed it New York in honour of his commanding officer, James, Duke of York. The memorial carries a cannon ball in its base, said to be the one that killed Colonel Nicolls during the Battle of Sole Bay in 1672.

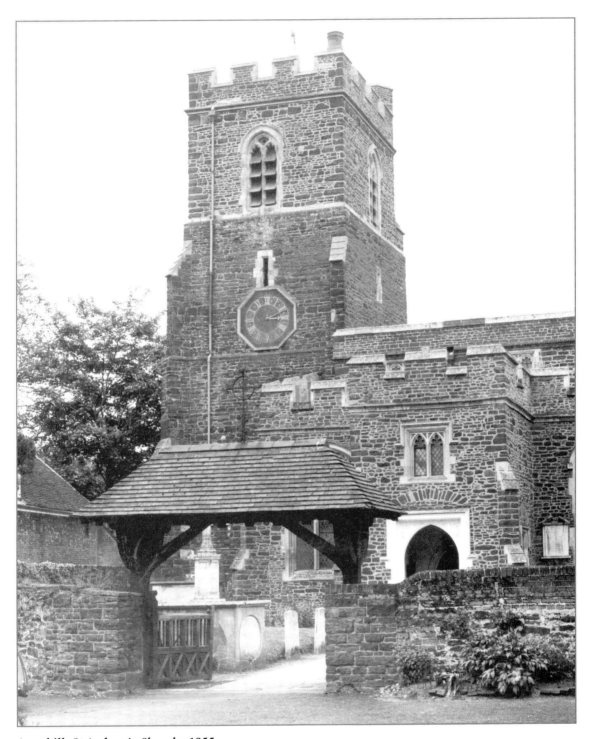

Ampthill, St Andrew's Church c1955 A158011
It is entirely possible that Queen Katherine of Aragon worshipped in the 10th-century church during her stay at Ampthill Castle in 1533. Katherine's Cross in Ampthill Park gained a subsequent measure of recognition when it proved to be the burial site of the 'Golden Hare' - the subject of a national treasure hunt based on Kit Williams' book 'Masquerade'.

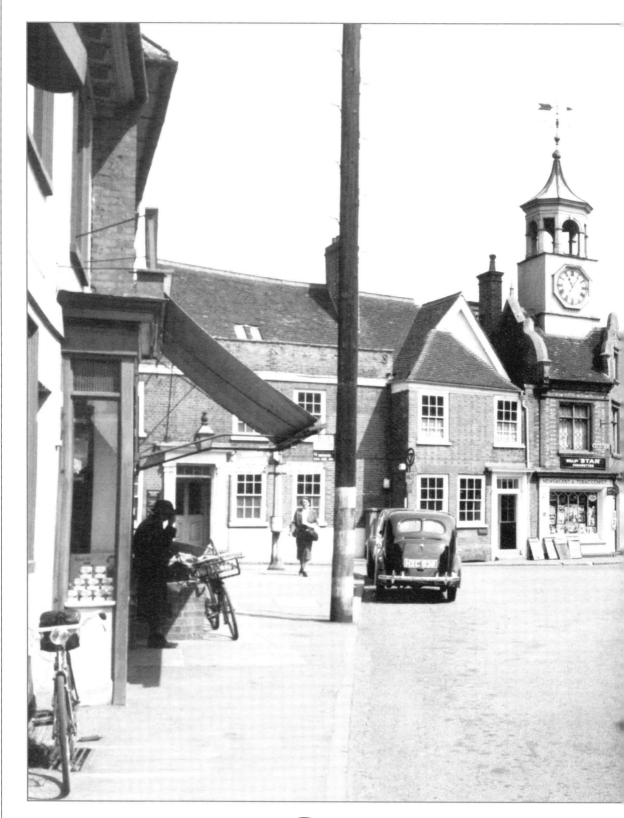

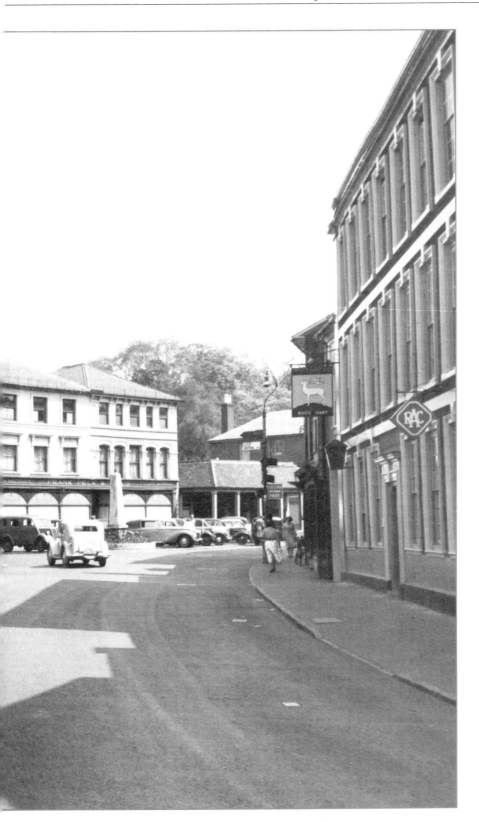

Ampthill
The Market Place
c1955 A158030
This substantial open space at the heart of the town is the original site of the Charter Market. All the main roads converge here, and Ampthill's history as a coaching stop is still visible in the form of the White Hart hotel on the right of the picture. Much of the building is of Tudor origin, but later additions are said to include panelling removed from Houghton House (see 39964). The Market Place has been redeveloped as a Millennium project.

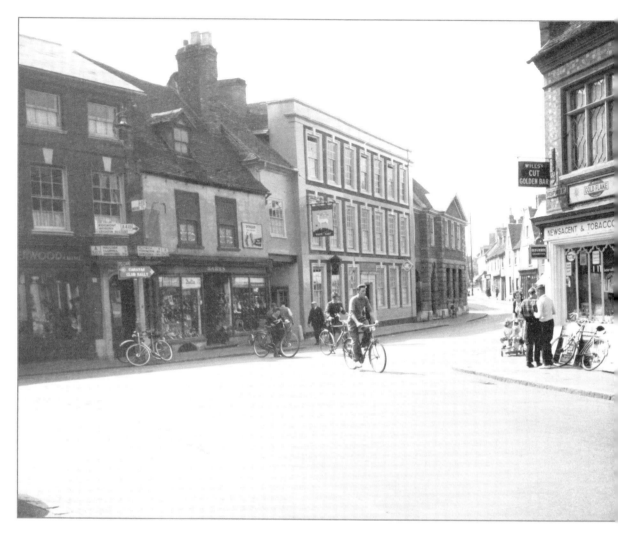

◀ **Ampthill**
Bedford Street c1955
A158021
The Zonita Cinema has followed 'Adventures of Quentin Durward' into obscurity, but the pub across the road still provides a service for thirsty residents and travellers. The owner, Charles Wells Brewery of Bedford, is the only independent brewery left in the county.

◄ Ampthill, Market Place c1955
A158028

In late morning sunshine, the boys of the village head for the newsagents, possibly to collect their wages for the daily delivery run. Behind them the Queen Anne façade of the White Hart hides the fabric of a Tudor building, while the structure housing Babbs footwear shop is not so bashful.

▼ Ampthill, Woburn Street c1955
A158007

Dating back to the 18th century, the deed to each of these cottages restricts the householder to replacing the thatched roof only with thatch, and further prescribes the method and colour of redecoration that may be carried out. It is doubtful that the legality of the covenant has ever been challenged. The bus on the right is an Eastern National vehicle operating the route between Ampthill and Bedford.

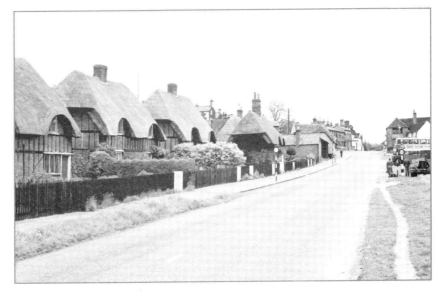

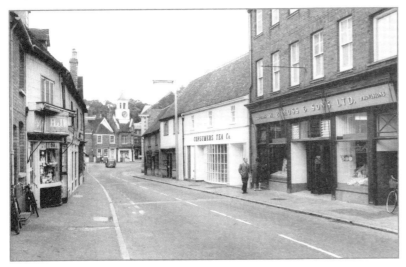

◄ Ampthill, Dunstable Street c1955 A158065

Dunstable Street housed most of the 'household' shops in 1955 - the situation has considerably altered since then as the town has expanded its boundaries.

W B Moss was a general dry goods store of quality, and the Consumers Tea Co next door offered a bewildering array of teas and coffees. Speciality shops occupied the other side of the road; from memory they included a haberdashers, a newsagents and tobacconists, and a cycle shop. At the bottom of the road is the clock tower overlooking the Market Place.

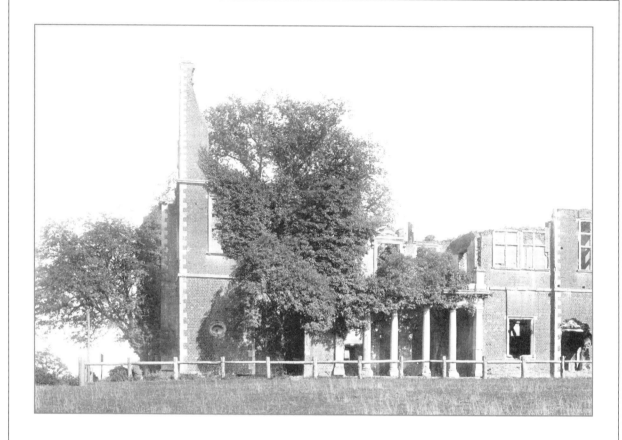

Houghton Conquest
Houghton House 1897 39964

Houghton House sits on a hill facing towards Ampthill. Lady
Pembroke, Sir Philip Sidney's sister, built the house between 1615
and 1621. The Bruce family bought it in 1624 and lived there for
nearly 70 years. It came into the possession of the Dukes of Bedford
in 1738, and in 1794 the then Duke removed the roof and most of
the fittings. The reason is not recorded. The staircase from Houghton
House, carrying the date of 1688, is in the Swan Hotel at Bedford. An
18th-century gateway with screen is located at 28 Church Street in
Ampthill, and panelling is alleged to be installed in the White Hart
hotel. The ruin is now scheduled as an ancient monument. Houghton
House is reputed to be the 'House Beautiful' of 'Pilgrim's Progress'.
Visitors viewing even the lessened magnificence of the present
building will not doubt the accuracy of the legend.

Bedford and the Surrounding Villages

First recorded as Bedanford in a document of 880, the town was awarded Borough status by Royal Charter in 1166. Bedford's importance is centred on its position astride the Great Ouse at the confluence of the A6, the A600 and A428 roads. The Town Bridge has long superseded the original ford, which was possibly guarded first by a Neolithic settlement, subsequently a Roman fort, then a Danish encampment, and finally by a Norman castle.

Such was the importance of the growing town as an administrative centre that the Sheriffs of neighbouring Buckinghamshire used the castle as their official seat for many years. The building was destroyed in 1224 as the result of a siege by Henry III's forces against Fawkes de Breauté. All that remains is the mound rising from behind the Bedford Museum in Castle Street.

As the centuries have progressed, the central positioning within the physical county of local government administration has become of increasing importance - despite the 20th-century rise in local economic input from the artificial city of Milton Keynes about 15 miles to the west. Fortunately, Bedford has lost nothing to the upstart - some 1100 years of recorded history starting with Beda and his

ford has seen to that.

The local government re-arrangements of 1974 meant that the boundaries of the town were expanded by the addition of the village of Kempston, which became redesignated an 'urban area' of Bedford. As a former inhabitant of what was - anecdotally at least - the largest village in England, it is with regret that I can no longer recommend a visit to this one-time pleasant backwater unless the reader happens to be a masochist specialising in a mixture of large trucks, hideous commercial buildings and an inadequate infrastructure. Far better to stick to the more select environs of Bedford town centre: it has at least retained its market town atmosphere without losing any of the advantages of existence in a modern world.

With the exception of Kempston, the villages surrounding the county town must be credited with being some of prettiest in England, and lose nothing by being side-tracked with the aid of relief roads and other forms of traffic control. This book can only accommodate a small selection, and so the likes of Pavenham, Bromham, Stagsden, Milton Ernest, Harrold, Ravensden and Stevington will have to wait their turn until another itinerant photographer passes through.

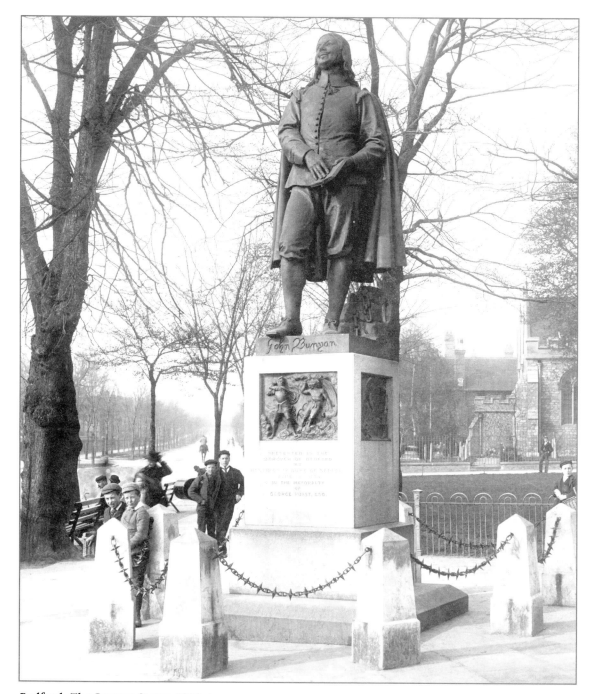

Bedford, The Bunyan Statue 1898 40857
Undoubtedly Bedford's most famous son - if only because of his imprisonment as the result of religious intolerance - John Bunyan was born into a tinker's family and lived something of the high life before becoming a Nonconformist preacher. In 1660 he was arrested for his beliefs and spent the next 12 years in prison. A major outcome of his hardships was the writing and publishing in 1678 of a religious parable - 'Pilgrims Progress'. It has become one of the most successful books ever written, being published in over 200 languages. Legend has it that it is possible to trace Pilgrim's journeying through various locations within the county, and the establishment of the 'John Bunyan Trail' attempts to add substance to the possibility.

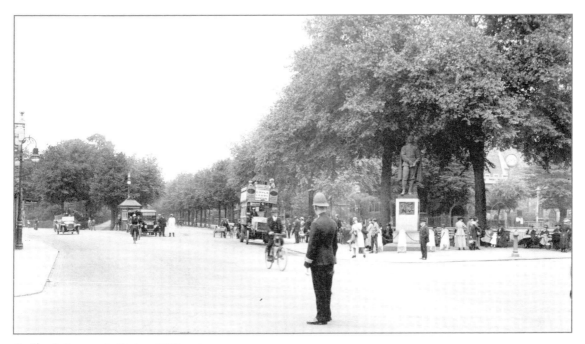

Bedford, Bunyan's Statue 1921 70428

Bedford, St Peter's Square c1955 B51061
Over thirty years and a world war separate these two photographs. Traffic is light enough to be controlled by a 'bobby' in 1921; by 1955 traffic lights and pedestrian crossings are required. The later image shows that the aspect of St Peter's Square is more open, with a lifted tree canopy over Bunyan's head and the removal of the railings around the gardens behind the statue. The clock on the church tower appears to have undergone a reversal of colour scheme.

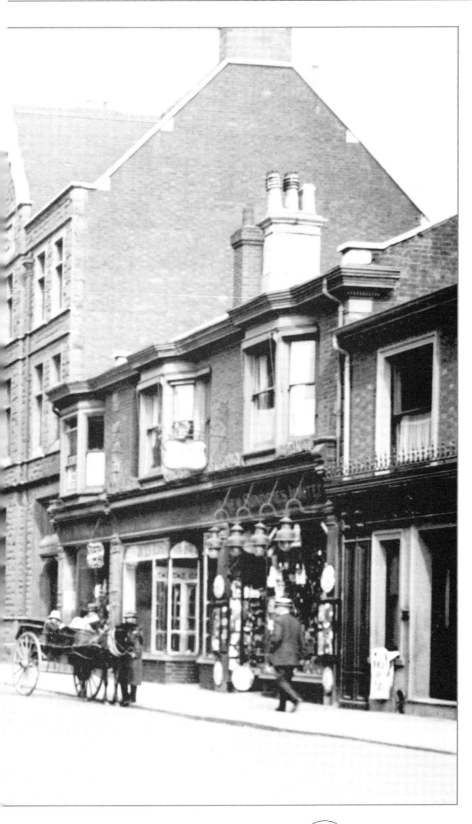

**Bedford
St Peter's Street
1921** 70426
This picture is remarkable for the diversity of personal transport it depicts. St Peter's Street is still as broad today as then, but it would be a brave cyclist who rode down its centre now. The sit-up-and-beg motorcycle sidecar is the latest for its day; Bill Swallow's Jaguar-preceding models were a full twelve months away. But the stalwart is the pony and trap waiting for 'Milady' to finish her shopping in the household goods store on the right. The majority of the visible buildings still exist, but with changed façades in most cases.

▼ **Bedford, The John Howard Statue and St Paul's Church 1897** 39940
Another great Nonconformist preacher dominates the Square at the opposite end
of the High Street to John Bunyan. In his time John Howard was derided for his
views, particularly when they spilled from religion into politics - never comfortable
bedfellows. He survived the difficulties, and spent many years campaigning against
conditions in the country's prisons and the indignities suffered by the inmates. His
name and work live on as the founder of the Howard League for Penal Reform.

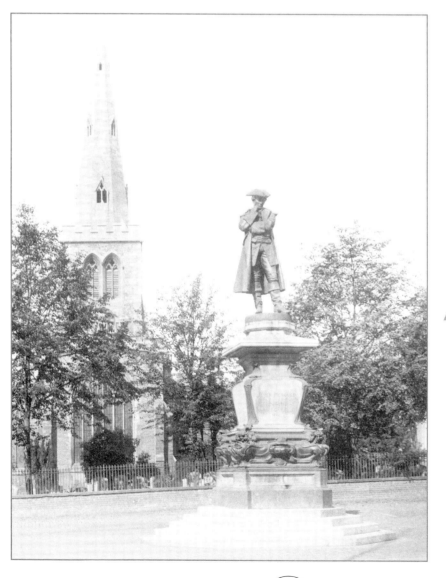

▲ **Bedford
St Paul's Square 1929**
81741
The event that prompted
this wonderful assembly of
motor vehicles of the day
was probably related to St
Paul's Church in the
background. Unfortunately,
history does not record
what it was. Students of
automobilia will have
pleasure in identifying the
marques on display -
certainly there are Vauxhalls
from nearby Luton, one or
two Morrises from Oxford
and possibly some early
foreign imports as well.

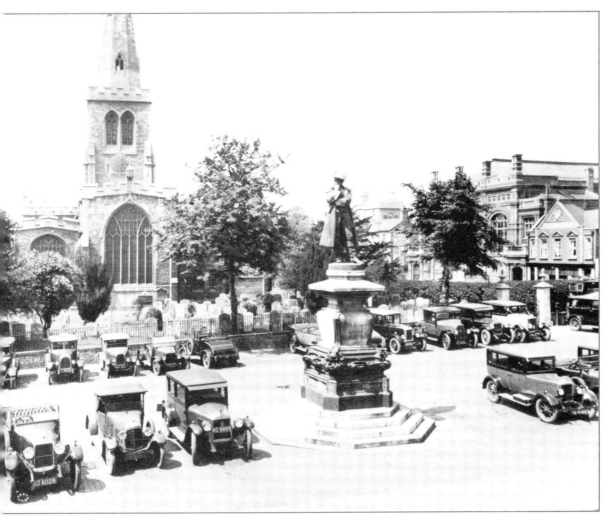

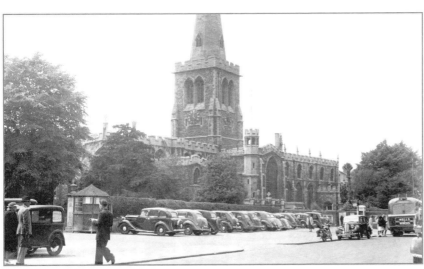

◀ **Bedford, St Pauls Square c1955** B51019
By 1955, all-day parking was a necessity for the many employees of shops and offices in the vicinity. The changes in vehicle design and equipment make the contrast with 81741 of particular interest. Note the Frith photographer's car parked in the lower left corner of the picture.

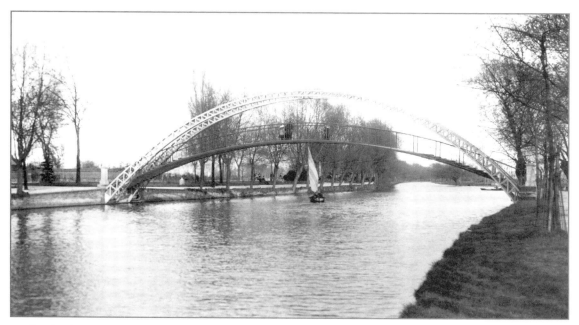

Bedford, The Suspension Footbridge over the Ouse 1898 40865
The Great Ouse has always been of importance to Bedford's economy and pleasure, and successive administrations have successfully managed the environs of the river to keep them as an amenity for the benefit of the citizens. The ability to promenade from one bank to the other via this bridge was further enhanced with the opening in 2000 of another, known as the Butterfly Bridge.

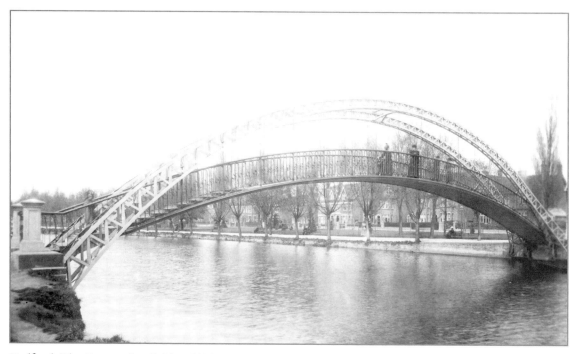

Bedford, The Suspension Bridge 1898 40864
Popular with all Bedfordians, the suspension bridge prevents a short stroll becoming a very long one. This shot is taken from the south side of the river with The Embankment in the background.

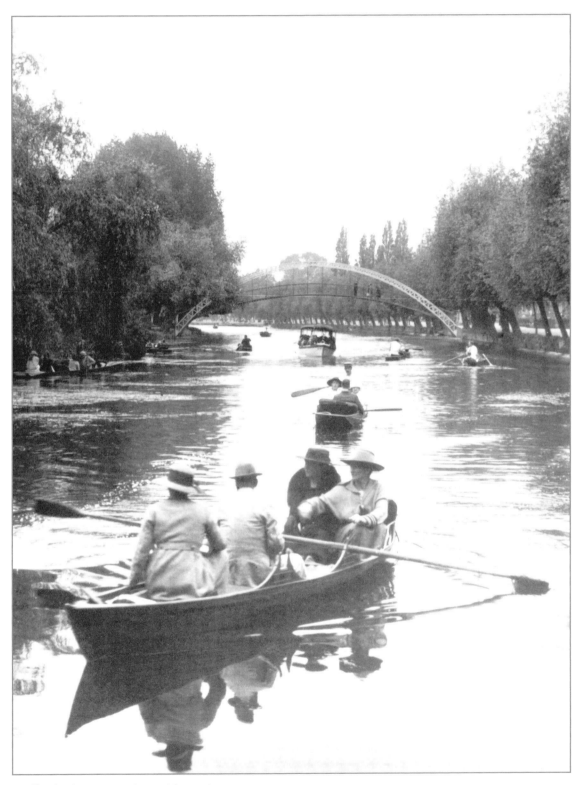

Bedford, The Suspension Bridge 1921 70446

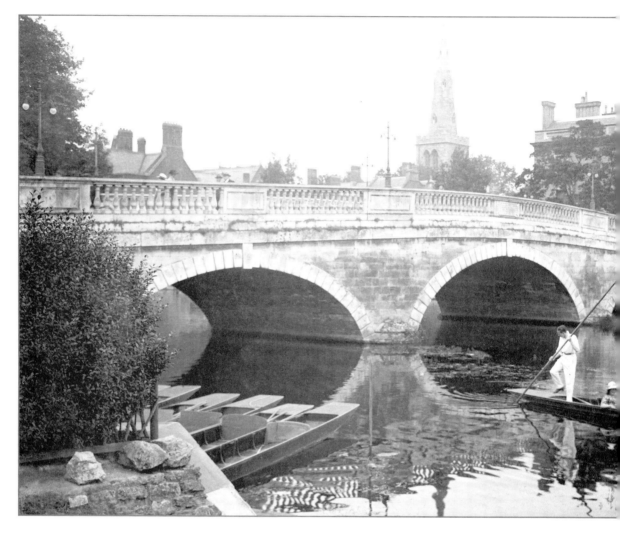

**Bedford
The Embankment
and the River 1921**
70443

◀ Bedford
The Town Bridge
1921 70434

These photographs confirm the enduring involvement of Bedford's citizens with their river. It is unlikely that one would find punts on the Great Ouse today, but many pleasure craft can be found where Roman merchants or Danish raiders once floated. The site occupied by the cinema in 1921 is now the headquarters of a rowing club, and a hotel stands on the southern end of Town Bridge.

▼ Bedford
The River and Town
Bridge 1921 70435

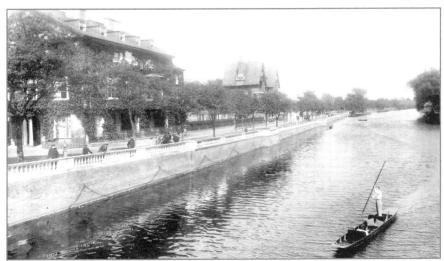

◀ Bedford
The Embankment and
the River Ouse 1929
81733
Any photographic survey of Bedford must include a picture of the embankment and the Swan Hotel. Standing almost squarely on the spot once occupied by Beda's ford (on Town Bridge), the photographer has captured the essence of a leisurely lifestyle.

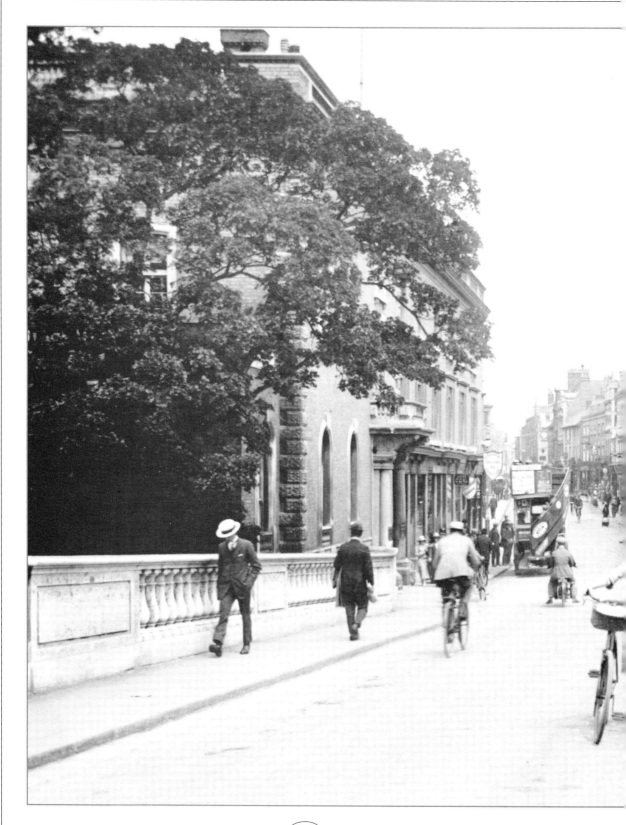

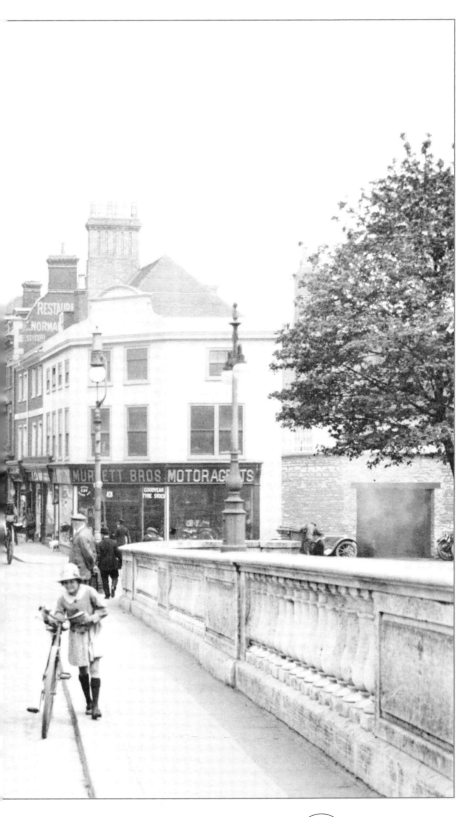

**Bedford
The High Street from
Town Bridge 1921**
70425
The photograph gives
an unusual perspective
in that the exit from the
bridge and the High
Street beyond appears
to be restrictive for both
traffic and pedestrians.
The actual width of the
road can be estimated
by assessing the relative
sizes of the open-top
bus and horse-drawn
vehicle passing it. The
motor agents' premises
on the right belong to
Murkett Bros, one of
the county's premier
automobile companies
which grew out of an
existing agricultural
machinery business
with its roots in the
19th century.

▼ **Bedford, St Paul's Square and the High Street c1955** B51020
Almost an exact repeat of 70425, taken 30 years earlier than this photograph, showing the road entrance to the Embankment on the right. Murkett Bros has long moved on, and the growth in traffic is exemplified by an equal increase in 'Keep Left' signs. The small market on the left is a relic of the town's original Royal Charter.

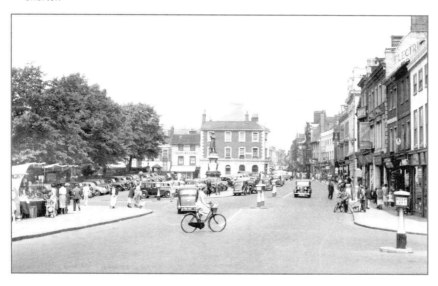

▼ **Bedford, The River Great Ouse c1955** B51015
Rowing sports have always played a large part in the leisure activities of Bedford's citizens. Bedford Rowing Club has produced a number of international athletes, including at least one current Olympic champion.

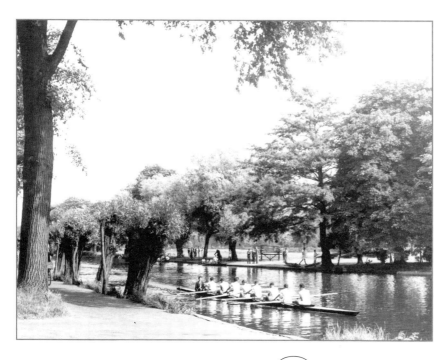

▲ **Bedford**
The High Street 1921
70423
The photographer stood at the northern end of the High Street for this picture. To modern eyes the phalanx of cyclists and two visible policemen lend an essence of quaintness. None of the trading names above the shops, nor the theatre-cum-cinema, have survived into the 21st century. The last to go was the Cadena Café that certainly existed in the 1960s.

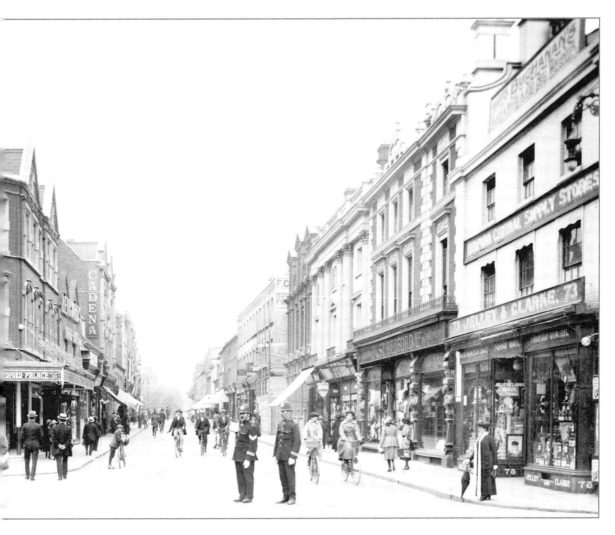

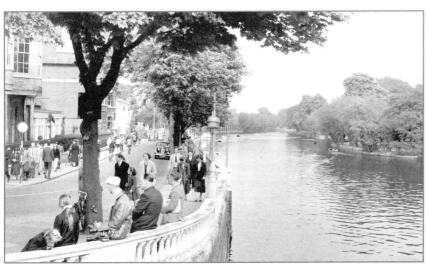

◀ **Bedford**
The River Great Ouse
and the Embankment
c1955 B51041
A typical street scene on this busy promenade. The building on the extreme left is the Bedford Swan Hotel, wherein may be found the staircase extracted from Houghton House in the 18th century. The Cecil Higgins Museum is next to the hotel, and to the rear of that is Castle Mound, the site of the Norman castle.

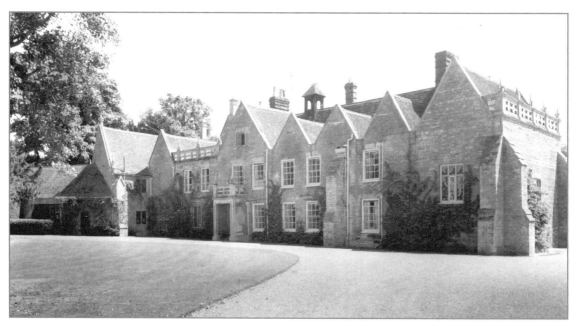

Turvey, The Abbey c1955 T90016
In 1786 Abbey Farm (now Turvey Abbey) was occupied by Charles Higgins Esq. The building has never been an abbey, but took its name from the lands owned by the Benedictine Abbey of Bec in Normandy. Two centuries later, in 1981, the Higgins heir of that time invited an order of Benedictine nuns to take residence - a situation that prevails today.

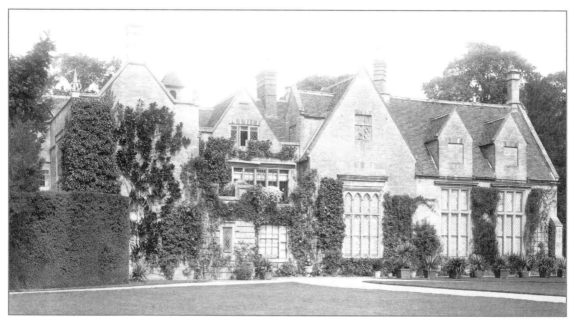

Turvey, The Abbey from the Gardens 1897 39973
At the time of the photograph the building was known as Abbey Farm; it had been the home of the Higgins family since 1786. At the end of the 18th century, much of the village was in disrepair because the previous owners, the Mordaunt family, were unable to afford the upkeep towards the end of their tenure. Cousins Charles and John Higgins rebuilt much of Turvey in the style we see today.

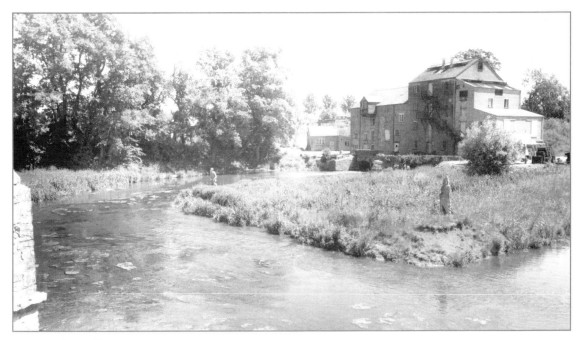

Turvey, The Mill c1955 T90021
A mill was recorded on this site in the Domesday survey of 1086, and underneath the buildings shown in this photograph are the footings of an earlier water-driven construction. The two figures on the eyot in the millpond are Jonah and his wife, reputedly brought to Turvey in 1844 from Ashridge House in Hertfordshire.

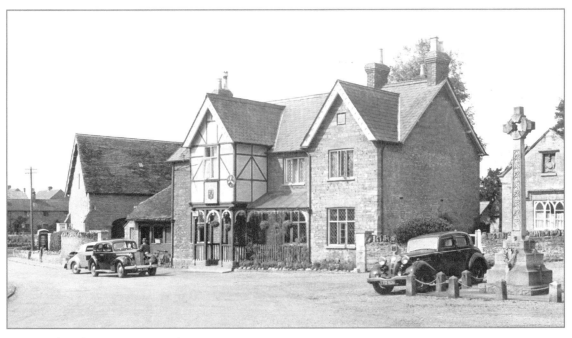

Turvey, The Three Cranes Hotel c1955 T90006
The building style established by Cecil Higgins is very much in evidence on the hotel. Note the old Cyclists Touring Club seal of approval carried above the front entrance. Birds figure strongly in the coats of arms for many old Bedfordshire families, and it is likely that the cranes of the hotel's title refer to one of these.

▼ Turvey, All Saints' Church c1955 T90015

Saxon remains incorporated into a medieval structure characterise All Saints'. Restorations carried out in the 19th century uncovered a 14th-century painting of the Crucifixion in the Lady Chapel. There are also many memorials to members of the Mordaunt family, which owned the lands until the late 1600s.

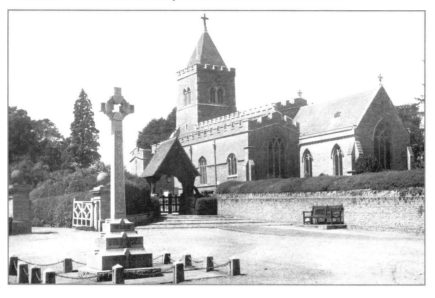

▼ Everton, The View from the Church Tower c1955 E166022

At one time straddling the county boundary with Huntingdonshire, Everton was listed as Euretone in the Domesday Book. The photographer's perch for this picture was the tower of St Mary's Church, itself built on the site of Saxon worship.

▲ Elstow, The Moot Hall 1921 39967

John Bunyan was born near Elstow, and made his adult home in the village. The Moot Hall shown in the photograph dates back to the 17th century, and was undoubtedly used by Bunyan for religious meetings. The guilty appearance of the boys suggests that they too enjoy the mildly hooligan pastimes that caused Bunyan so much angst in later life.

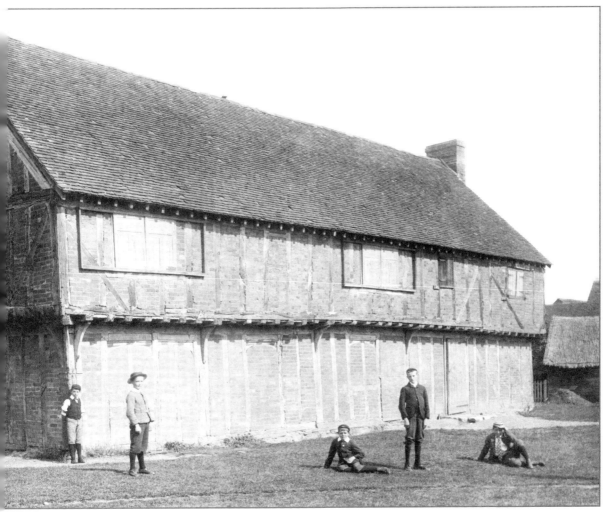

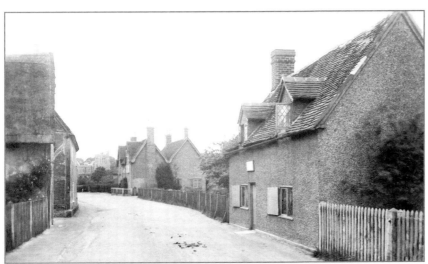

◄ **Elstow**
Bunyan's Cottage and the
Village 1921 70453
The wooden plaque above
the door of the cottage on
the right proclaims it as
John Bunyan's home. The
village is not a great deal
larger than is indicated in
the picture. The majority of
the buildings are in whole
or part 17th-century in
origin.

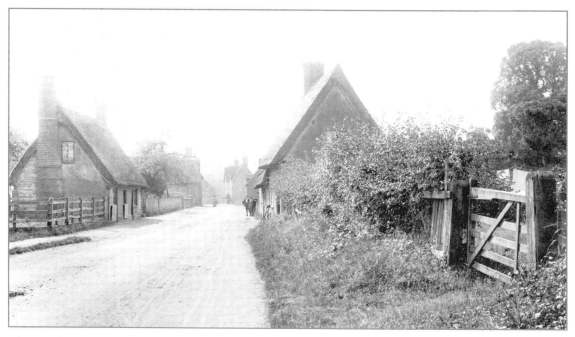

Elstow, The Village 1897 39966

Elstow, Bunyan's Cottage 1921 39968
As should be expected of the founder of a religious concept, John Bunyan's home and the village in which it stands have almost become a place of pilgrimage. His tribulations and his works, of which 'Pilgrim's Progress' might be the best known but is far from singular, are celebrated in the establishment of the Bunyan Trail. This 75-mile-long footpath winds through the Bedfordshire countryside linking elements of Pilgrim's journeys and the more factual aspects of Bunyan's life.

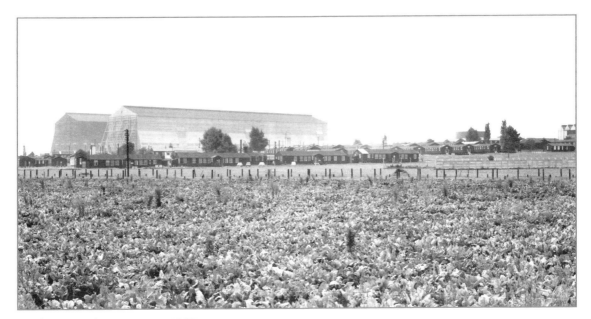

Cardington, The RAF Base c1955 C325013
Generations of Royal Air Force recruits will recognise the huts and airship sheds beyond the cabbage field. The sheds were constructed during World War I for the development of airships. Tall enough to contain Nelson's Column and long enough to hold an ocean-going liner, it is possible - in certain conditions - for condensation to fall as rain inside the buildings. During World War II, and after, Cardington became part of Britain's air defence system and produced barrage balloons and trained the personnel to handle them.

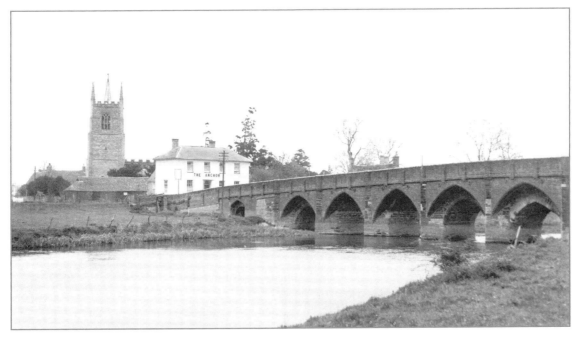

Great Barford, The Bridge c1955 G141014
The 15th-century tower of All Saints, the Anchor pub and the elevation of the bridge, which is medieval in origin with 19th-century additions, add up to a classic photograph of the entrance to the village. Barford straddles the busy A418 road and has suffered architecturally as a consequence.

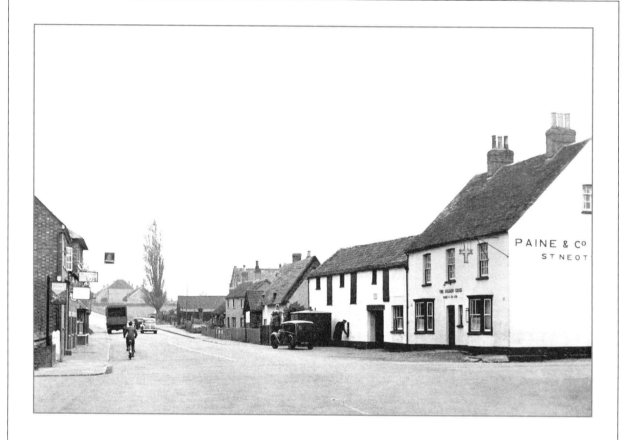

Great Barford
The Cross c1955 G141003
Sited at the critical junction of the A428 Bedford/St Neots,
Blunham/Staughtons roads, it is perhaps not surprising to find
opportunity for a variety of forms of refreshment. Whether the
Golden Cross refers to the pub's position or to its proximity to All
Saints Church is unrecorded, but in 1955 it was unusual to find a
St Neots brewery supplying this far into Bedfordshire.

Biggleswade, Potton, Sandy & Nearby Villages

Distinctly agrarian in nature, Biggleswade, Potton and Sandy are all towns in the east of the county with substantial populations. However, as with Bedford, the social content of all three has been considerably altered by the advent of fast road and rail links to London. There are more housing developments built for the commuter market than for the dwindling numbers of rural and agricultural workers, but as long as they are reasonably contained, there can be little wrong with this situation. Without the incomers it is likely that small market towns such as these three would atrophy and die back; as it is, they are lively communities with almost boundless energy and fresh ideas with which to build and sustain a healthy growth in the local economies.

Similar, but smaller, is the market town of Shefford. Again, it is a lively community, but with a greater dependence on local employment. A claim to fame is that Shefford was once an inland port; during the 19th century there was a navigable waterway linking it to King's Lynn in Norfolk.

Biggleswade, The Ford c1955 B93072X
'Biccel's waed' in Old English is the origin of the town's name, and, as closely as can be ascertained, this is the ford - or waed - of the title.

▼ **Biggleswade, The Ford c1955** B93054
The River Ivel is often deeper than is comfortable to walk through. The
packhorse bridge was originally built in the 10th century as a wooden
structure and progressed to this design 200 years later. Since then it has
been a case of repair and refurbish at irregular intervals.

▼ **Biggleswade, The Recreation Ground c1955** B93069
An ornamental lake and a bandstand may seem to be anachronistic in
a rural community, but the park has been at the heart of many
successful events and family outings for most of the 20th century.

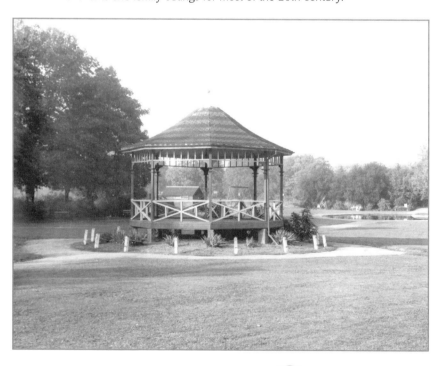

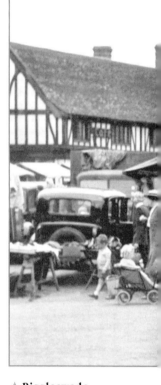

▲ **Biggleswade
The Market Square
c1955** B93006
Much of the life of the
town revolves around the
Saturday influx to the
weekly market. To cater
for both thirst and the
sometime necessity to sit
down to do business,
Market Square is
surrounded by pubs and
cafes. The roof of the
Market House, to the left
of the picture, dates back
to the 16th century and
was preserved when
road-widening operations
took place in 1937.

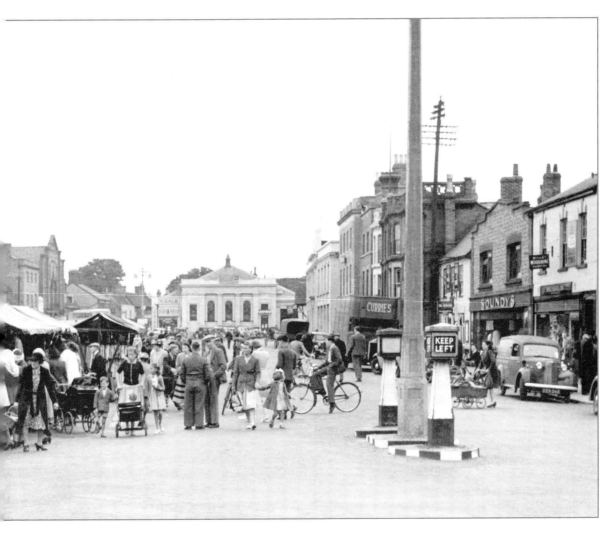

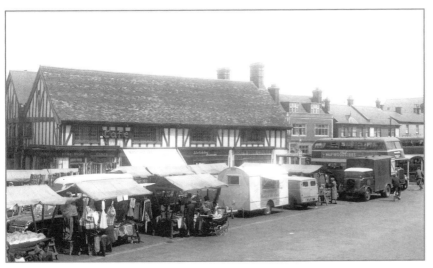

◀ **Biggleswade
Market Place c1955**
B93015
Café, jeweller, dry cleaners and the regional newspaper office make strange bedfellows under the roof of the old Market House. A baby fashion note is the coach-built pram in the foreground, a pre-requisite when cars were still luxury items.

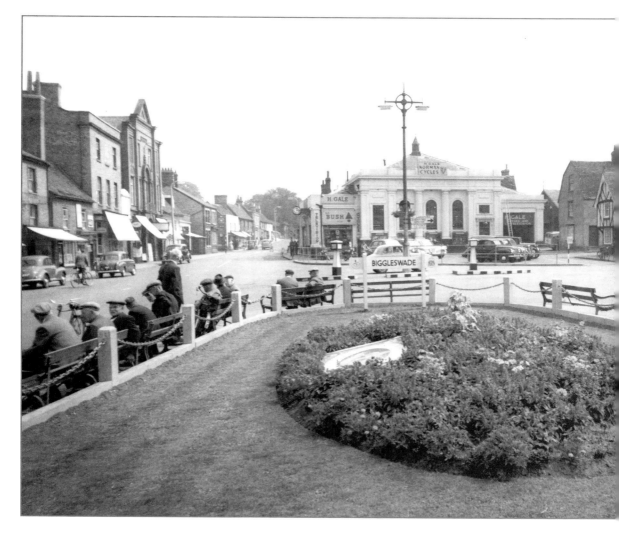

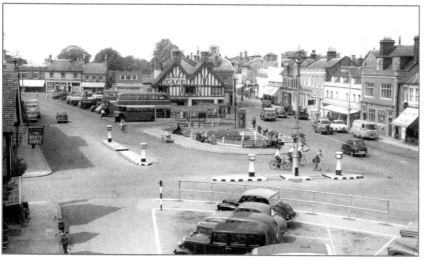

◀ **Biggleswade Market Place c1955**
B93048
A quiet day in the Market Place when it reverts to its more usual function of bus station and car park. The function of the cross supported on the pole in the middle foreground is not recorded, but logic suggests that it might be the site for an original market cross.

Biggleswade
The Market Place c1955 B93046
A 'tidy' view of Market Square complete with flower beds, mown grass and full benches just before opening time. Many of the buildings surrounding the Square show evidence of ancient origins. In particular, the White Hart on the right and the hipped-roof building next to it have been on the site since the 16th century.

Biggleswade
The Market Place c1955 B93026
This closer view of Market House also reveals the Crown Hotel (on the other side of the High Street and next to Larkinson's shop) which was the source of the Great Fire of Biggleswade in 1785.

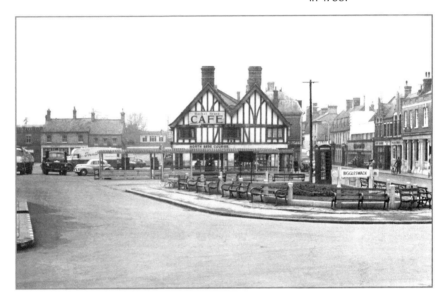

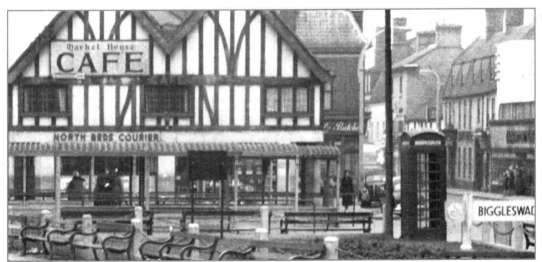

Detail from B93026

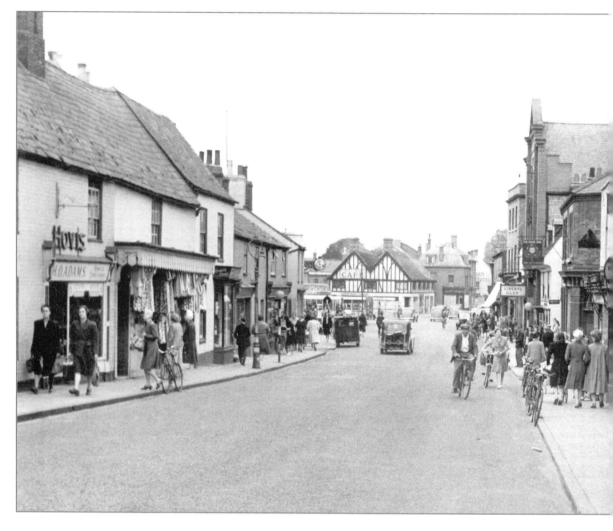

◄ **Biggleswade
High Street c1955**
B93032

◀ **Biggleswade**
High Street c1955
B93010

Although obviously taken on different days, these pictures of the High Street illustrate Biggleswade's heritage as a market town. The dependency on bicycles as a means of personal transport gives rise to a plethora of cycle shops (three within half-a-mile), and the even more frequent pubs, indicate the farming community's necessity to slake its thirst over a market deal. The town has undergone a major make-over since 1997, but such has been the sensitivity displayed by the planners that Biggleswade has lost nothing but gained much.

▼ **Biggleswade**
High Street c1955
B93031

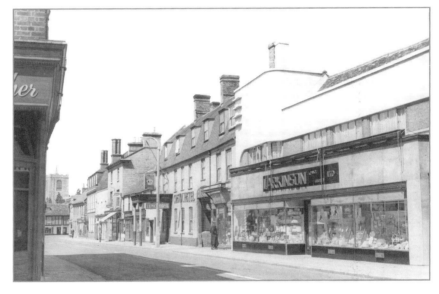

◀ **Biggleswade**
High Street c1955
B93051

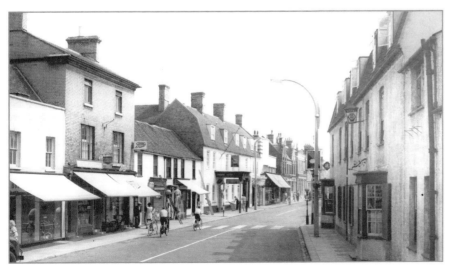

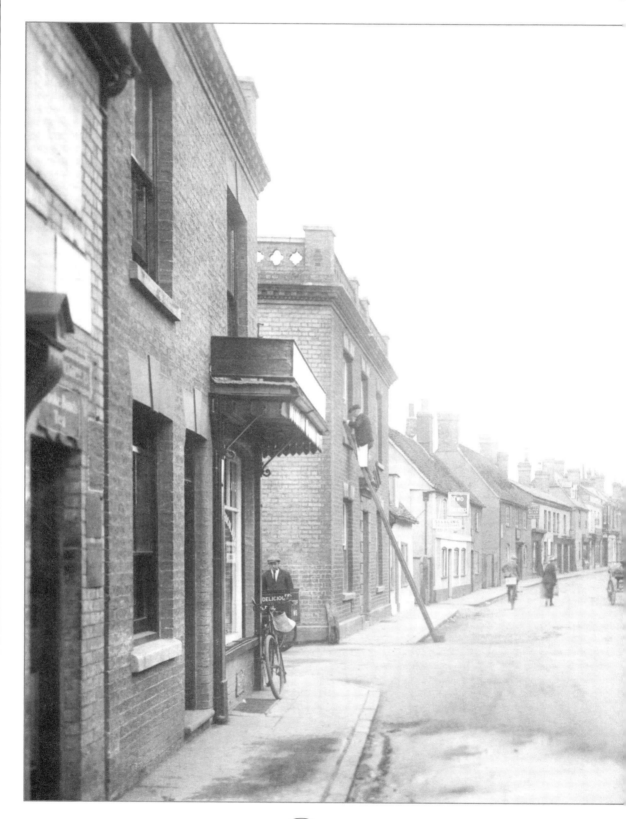

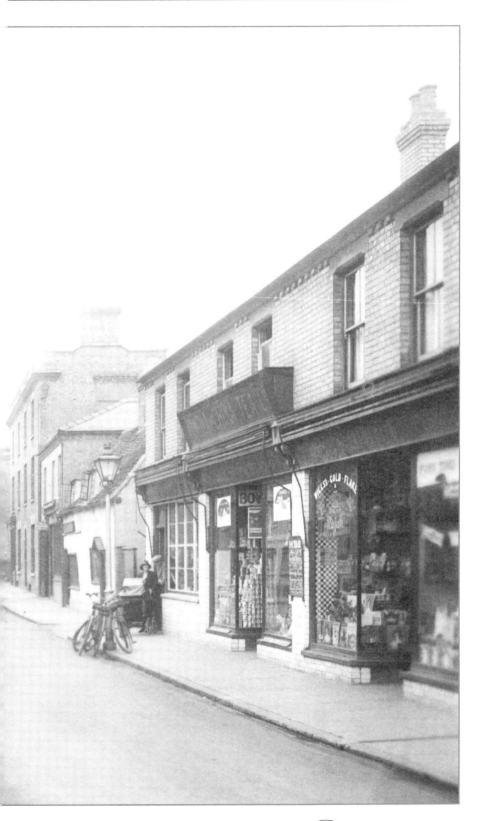

**Biggleswade
Hitchin Street 1925**

77217

An interesting picture revealing the extent of the differences in working practices that have occurred over 75 years. Tucked into the entrance on the left, the trader's cart that suggests a mobile ice-cream seller would be a motorised parlour and probably banned under a ton of directives nowadays. The Health and Safety Executive would take a very dim view of the decorator's ladder without any assistance at ground level and not a traffic cone in sight. Bicycles piled against the lamp post on the right constitute a thief's delight with not a padlock and chain between them. And the piled tins in the shop window? Just imagine what a 21st-century toddler could do with those.

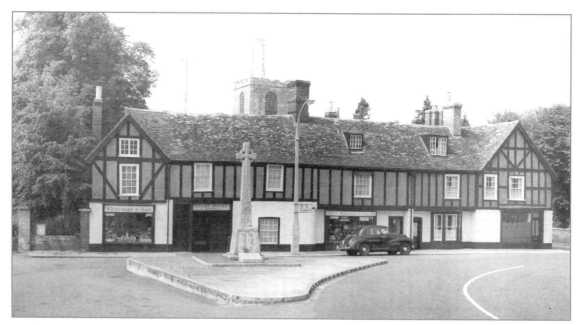

Biggleswade, The War Memorial c1955 B93050
Reflecting the town's original location on that highway beloved of cyclists, the Great North Road, the sign to the rear of the memorial promises 'Cycles Stored and Repaired'. The memorial, with its scrolls commemorating the dead of two world wars, has now been cleaned and moved to a site of even greater prominence in the newly refurbished town centre. The scheme was completed and reopened on 27 September 1998.

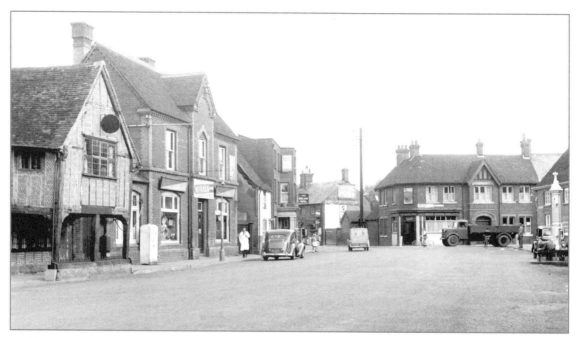

Shefford, North Bridge Street 1951 S378007
Shefford's title derives from the name 'Sheepford', an indication of its origins. Sheep on the High Street are a distant memory, but the town has managed to preserve a number of older buildings - including the 16th-century porch on the left. Despite its moderately tumble-down appearance, The Porch is now a bank.

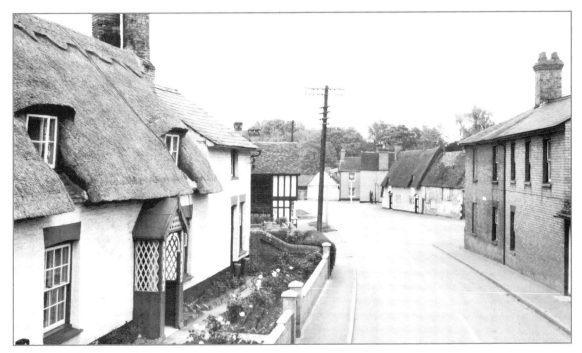

Blunham, The Hill and the Square 1968 B295013
This village's most famous resident was the preacher and poet, Dr John Donne. He was Rector of Blunham from 1621 until his death in 1631, during which period he also held the post of Dean of St Paul's Cathedral, London.

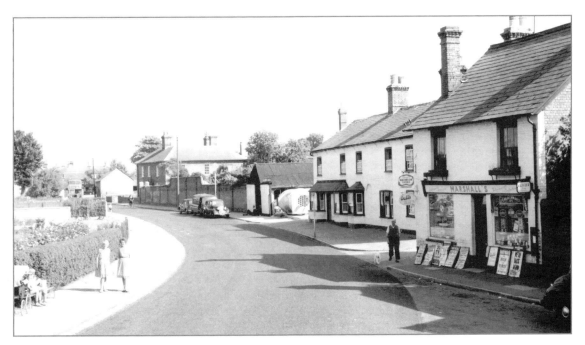

Stotfold, High Street 1959 S382030
The village is set solidly in the heart of market gardening country, and Stotfold's name is a carry forward of the Old English title for a pigpen. A number of smaller businesses have built up around this pleasant village, some evidence of which is seen in the yard in the centre of the photograph.

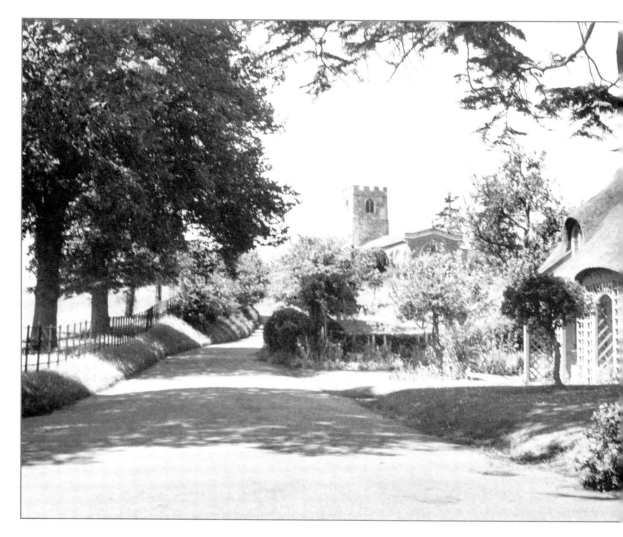

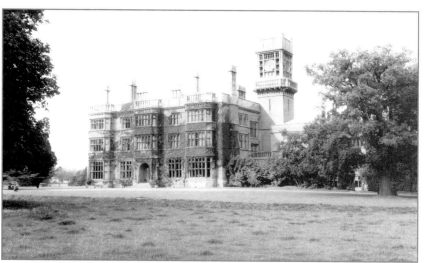

◄ **Old Warden Shuttleworth College c1955** 0124005
The village is home to both the College and the Shuttleworth Trust. The latter is dedicated to the life of the eldest son of the family who was killed in World War II, and supports the Shuttleworth Collection of road transport and aircraft housed at Old Warden Aerodrome.

Old Warden
The Church and
Thatched Cottages c1955
0124001
This chocolate box view has been carefully preserved by the beneficial presence of the local landowners, the Ongley and Shuttleworth families, for almost 200 years. St Leonard's church is a 12th-century building standing on a small hill to overlook the village.

Old Warden
The Thatched House
c1955 0124007
An ornamental Swiss Garden in Old Warden Park complements the Swiss styling that was built into the village by the third Lord Ongley in the 19th century. The Swiss Garden is open to the public.

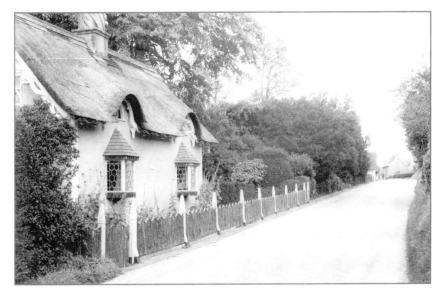

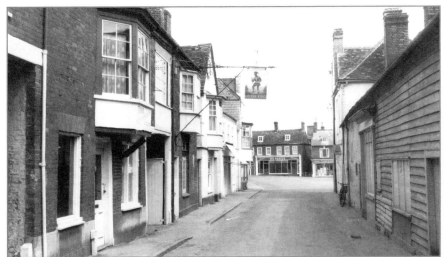

Potton
The Green Man c1955
P130048
Potton's market existed at the beginning of the 13th century, and the town owes much of its present layout to that period. In the early 1900s a count revealed the existence of 32 alehouses. There are still seven at the last count, and the town boasts its own independent brewery.

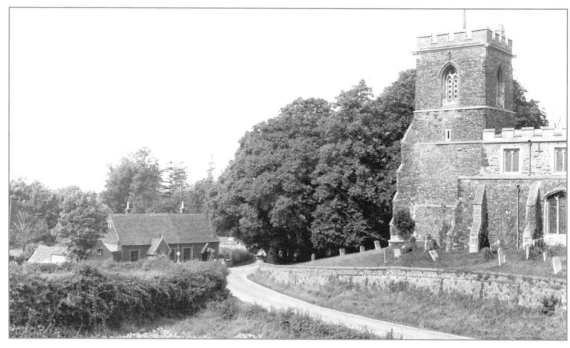

Potton, St Mary's Church and the School c1955 P130014
Originally part of the Earldom of Huntingdon, Potton's parish church owes its architectural features to the Norman influence during the 12th century.

Potton, Biggleswade Road c1955 P130016
The homes in the middle distance would have been built to house the employees of the many market gardens in the area. Those closer to the camera were probably erected after the First World War, but have now been incorporated into the many housing estates built since the 1960s.

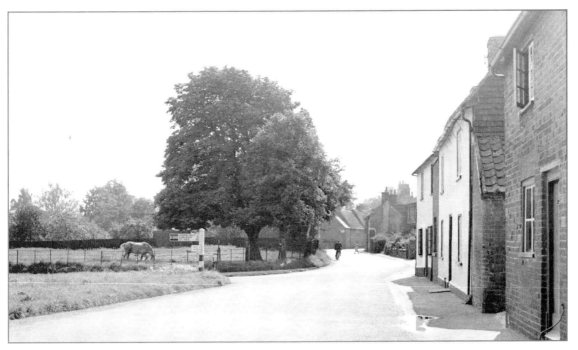

Potton, King Street c1955 P130018
Bedfordshire brick and pantiles on the roofs place this row of cottages fronting on to the street in the early 19th century. The doorway nearest to the camera appears to have a forged bootscraper built into the wall.

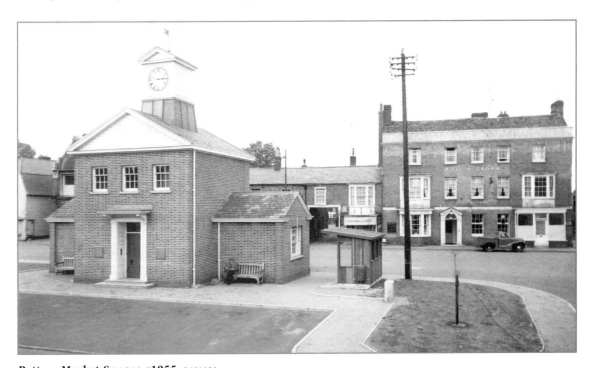

Potton, Market Square c1955 P130033
Potton Clock House was opened in 1955, replacing a much older building. The original clock tower stood in an area known as The Shambles, and was surrounded by small shops.

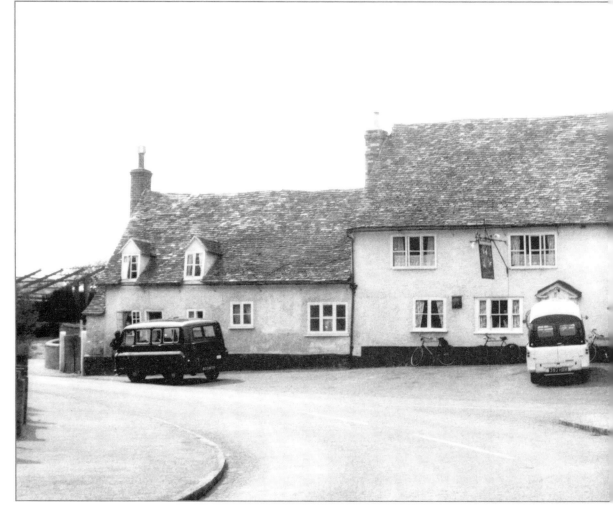

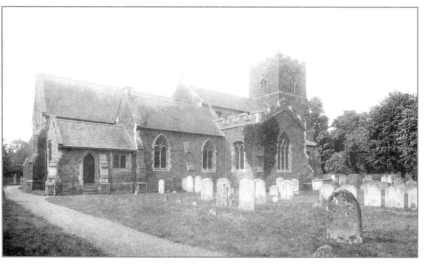

◀ **Sandy**
St Swithun's Church
1925 77232
The earliest mention of a church in Sandy is in the institution rolls of Bishop Hugh of Wells (c1214), and the font bowl in the south aisle is thought to date from Saxon times.

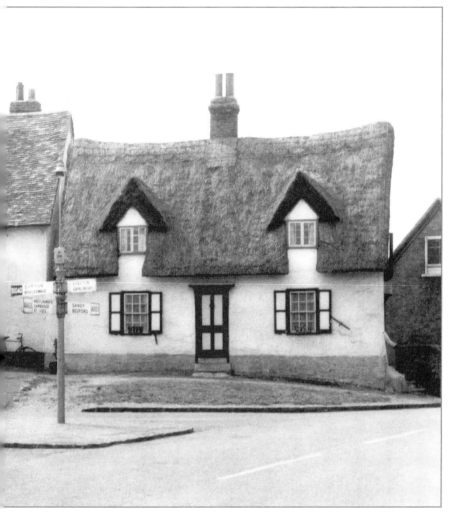

◄ **Potton, The Royal Oak c1955** P130045
If we remember that Bedfordshire was solidly on the side of the Parliamentarians during the English Civil War, it is surprising to find a number of references to King Charles's ability to hide himself from his foes. Or maybe the pub title confers an even more tenuous link with Henry VIII's navy.

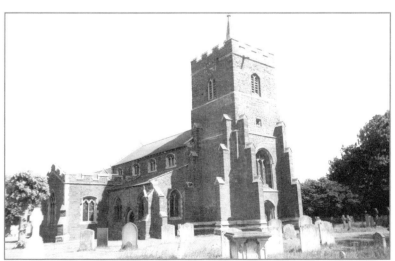

◄ **Sandy, St Swithun's Church c1955** S61013
The earliest building work visible dates from the 15th century, and extensive 19th-century restoration means that apart from the west tower very little earlier work can be seen. The Church of England School dates back to Victorian times, and occupied a site at the top of St Neots Road until 1987, when it was transferred to its present location in Ivel Road.

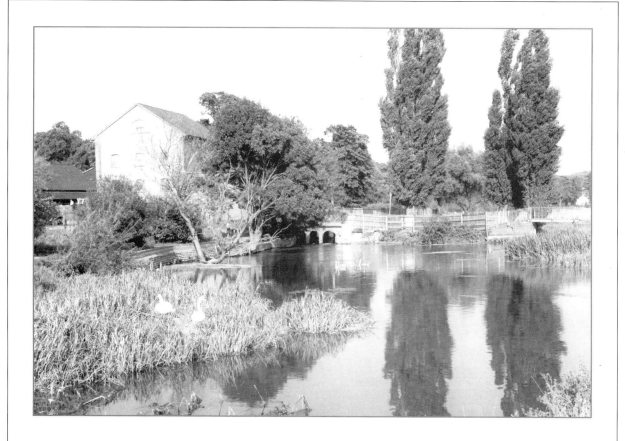

Sandy
The Mill c1955 S61019
Never a very large town, Sandy owes its continued existence to the
strength of the produce market in Victorian England. When the
railway came in 1850, it opened up the voracious wholesale
markets of London and the Midlands and brought a measure of
solid prosperity to the community.

Index

Frith Book Co Titles

www.francisfrith.co.uk

The Frith Book Company publishes over 100 new titles each year. A selection of those currently available are listed below. For latest catalogue please contact Frith Book Co.

Town Books 96 pages, approx 100 photos. County and Themed Books 128 pages, approx 150 photos (unless specified). All titles hardback laminated case and jacket except those indicated pb (paperback)

Amersham, Chesham & Rickmansworth (pb)			Derby (pb)	1-85937-367-4	£9.99
	1-85937-340-2	£9.99	Derbyshire (pb)	1-85937-196-5	£9.99
Ancient Monuments & Stone Circles	1-85937-143-4	£17.99	Devon (pb)	1-85937-297-x	£9.99
Aylesbury (pb)	1-85937-227-9	£9.99	Dorset (pb)	1-85937-269-4	£9.99
Bakewell	1-85937-113-2	£12.99	Dorset Churches	1-85937-172-8	£17.99
Barnstaple (pb)	1-85937-300-3	£9.99	Dorset Coast (pb)	1-85937-299-6	£9.99
Bath (pb)	1-85937419-0	£9.99	Dorset Living Memories	1-85937-210-4	£14.99
Bedford (pb)	1-85937-205-8	£9.99	Down the Severn	1-85937-118-3	£14.99
Berkshire (pb)	1-85937-191-4	£9.99	Down the Thames (pb)	1-85937-278-3	£9.99
Berkshire Churches	1-85937-170-1	£17.99	Down the Trent	1-85937-311-9	£14.99
Blackpool (pb)	1-85937-382-8	£9.99	Dublin (pb)	1-85937-231-7	£9.99
Bognor Regis (pb)	1-85937-431-x	£9.99	East Anglia (pb)	1-85937-265-1	£9.99
Bournemouth	1-85937-067-5	£12.99	East London	1-85937-080-2	£14.99
Bradford (pb)	1-85937-204-x	£9.99	East Sussex	1-85937-130-2	£14.99
Brighton & Hove(pb)	1-85937-192-2	£8.99	Eastbourne	1-85937-061-6	£12.99
Bristol (pb)	1-85937-264-3	£9.99	Edinburgh (pb)	1-85937-193-0	£8.99
British Life A Century Ago (pb)	1-85937-213-9	£9.99	England in the 1880s	1-85937-331-3	£17.99
Buckinghamshire (pb)	1-85937-200-7	£9.99	English Castles (pb)	1-85937-434-4	£9.99
Camberley (pb)	1-85937-222-8	£9.99	English Country Houses	1-85937-161-2	£17.99
Cambridge (pb)	1-85937-422-0	£9.99	Essex (pb)	1-85937-270-8	£9.99
Cambridgeshire (pb)	1-85937-420-4	£9.99	Exeter	1-85937-126-4	£12.99
Canals & Waterways (pb)	1-85937-291-0	£9.99	Exmoor	1-85937-132-9	£14.99
Canterbury Cathedral (pb)	1-85937-179-5	£9.99	Falmouth	1-85937-066-7	£12.99
Cardiff (pb)	1-85937-093-4	£9.99	Folkestone (pb)	1-85937-124-8	£9.99
Carmarthenshire	1-85937-216-3	£14.99	Glasgow (pb)	1-85937-190-6	£9.99
Chelmsford (pb)	1-85937-310-0	£9.99	Gloucestershire	1-85937-102-7	£14.99
Cheltenham (pb)	1-85937-095-0	£9.99	Great Yarmouth (pb)	1-85937-426-3	£9.99
Cheshire (pb)	1-85937-271-6	£9.99	Greater Manchester (pb)	1-85937-266-x	£9.99
Chester	1-85937-090-x	£12.99	Guildford (pb)	1-85937-410-7	£9.99
Chesterfield	1-85937-378-x	£9.99	Hampshire (pb)	1-85937-279-1	£9.99
Chichester (pb)	1-85937-228-7	£9.99	Hampshire Churches (pb)	1-85937-207-4	£9.99
Colchester (pb)	1-85937-188-4	£8.99	Harrogate	1-85937-423-9	£9.99
Cornish Coast	1-85937-163-9	£14.99	Hastings & Bexhill (pb)	1-85937-131-0	£9.99
Cornwall (pb)	1-85937-229-5	£9.99	Heart of Lancashire (pb)	1-85937-197-3	£9.99
Cornwall Living Memories	1-85937-248-1	£14.99	Helston (pb)	1-85937-214-7	£9.99
Cotswolds (pb)	1-85937-230-9	£9.99	Hereford (pb)	1-85937-175-2	£9.99
Cotswolds Living Memories	1-85937-255-4	£14.99	Herefordshire	1-85937-174-4	£14.99
County Durham	1-85937-123-x	£14.99	Hertfordshire (pb)	1-85937-247-3	£9.99
Croydon Living Memories	1-85937-162-0	£9.99	Horsham (pb)	1-85937-432-8	£9.99
Cumbria	1-85937-101-9	£14.99	Humberside	1-85937-215-5	£14.99
Dartmoor	1-85937-145-0	£14.99	Hythe, Romney Marsh & Ashford	1-85937-256-2	£9.99

Available from your local bookshop or from the publisher

Frith Book Co Titles (continued)

Ipswich (pb)	1-85937-424-7	£9.99	St Ives (pb)	1-85937415-8	£9.99
Ireland (pb)	1-85937-181-7	£9.99	Scotland (pb)	1-85937-182-5	£9.99
Isle of Man (pb)	1-85937-268-6	£9.99	Scottish Castles (pb)	1-85937-323-2	£9.99
Isles of Scilly	1-85937-136-1	£14.99	Sevenoaks & Tunbridge	1-85937-057-8	£12.99
Isle of Wight (pb)	1-85937-429-8	£9.99	Sheffield, South Yorks (pb)	1-85937-267-8	£9.99
Isle of Wight Living Memories	1-85937-304-6	£14.99	Shrewsbury (pb)	1-85937-325-9	£9.99
Kent (pb)	1-85937-189-2	£9.99	Shropshire (pb)	1-85937-326-7	£9.99
Kent Living Memories	1-85937-125-6	£14.99	Somerset	1-85937-153-1	£14.99
Lake District (pb)	1-85937-275-9	£9.99	South Devon Coast	1-85937-107-8	£14.99
Lancaster, Morecambe & Heysham (pb)	1-85937-233-3	£9.99	South Devon Living Memories	1-85937-168-x	£14.99
Leeds (pb)	1-85937-202-3	£9.99	South Hams	1-85937-220-1	£14.99
Leicester	1-85937-073-x	£12.99	Southampton (pb)	1-85937-427-1	£9.99
Leicestershire (pb)	1-85937-185-x	£9.99	Southport (pb)	1-85937-425-5	£9.99
Lincolnshire (pb)	1-85937-433-6	£9.99	Staffordshire	1-85937-047-0	£12.99
Liverpool & Merseyside (pb)	1-85937-234-1	£9.99	Stratford upon Avon	1-85937-098-5	£12.99
London (pb)	1-85937-183-3	£9.99	Suffolk (pb)	1-85937-221-x	£9.99
Ludlow (pb)	1-85937-176-0	£9.99	Suffolk Coast	1-85937-259-7	£14.99
Luton (pb)	1-85937-235-x	£9.99	Surrey (pb)	1-85937-240-6	£9.99
Maidstone	1-85937-056-x	£14.99	Sussex (pb)	1-85937-184-1	£9.99
Manchester (pb)	1-85937-198-1	£9.99	Swansea (pb)	1-85937-167-1	£9.99
Middlesex	1-85937-158-2	£14.99	Tees Valley & Cleveland	1-85937-211-2	£14.99
New Forest	1-85937-128-0	£14.99	Thanet (pb)	1-85937-116-7	£9.99
Newark (pb)	1-85937-366-6	£9.99	Tiverton (pb)	1-85937-178-7	£9.99
Newport, Wales (pb)	1-85937-258-9	£9.99	Torbay	1-85937-063-2	£12.99
Newquay (pb)	1-85937-421-2	£9.99	Truro	1-85937-147-7	£12.99
Norfolk (pb)	1-85937-195-7	£9.99	Victorian and Edwardian Cornwall	1-85937-252-x	£14.99
Norfolk Living Memories	1-85937-217-1	£14.99	Victorian & Edwardian Devon	1-85937-253-8	£14.99
Northamptonshire	1-85937-150-7	£14.99	Victorian & Edwardian Kent	1-85937-149-3	£14.99
Northumberland Tyne & Wear (pb)	1-85937-281-3	£9.99	Vic & Ed Maritime Album	1-85937-144-2	£17.99
North Devon Coast	1-85937-146-9	£14.99	Victorian and Edwardian Sussex	1-85937-157-4	£14.99
North Devon Living Memories	1-85937-261-9	£14.99	Victorian & Edwardian Yorkshire	1-85937-154-x	£14.99
North London	1-85937-206-6	£14.99	Victorian Seaside	1-85937-159-0	£17.99
North Wales (pb)	1-85937-298-8	£9.99	Villages of Devon (pb)	1-85937-293-7	£9.99
North Yorkshire (pb)	1-85937-236-8	£9.99	Villages of Kent (pb)	1-85937-294-5	£9.99
Norwich (pb)	1-85937-194-9	£8.99	Villages of Sussex (pb)	1-85937-295-3	£9.99
Nottingham (pb)	1-85937-324-0	£9.99	Warwickshire (pb)	1-85937-203-1	£9.99
Nottinghamshire (pb)	1-85937-187-6	£9.99	Welsh Castles (pb)	1-85937-322-4	£9.99
Oxford (pb)	1-85937-411-5	£9.99	West Midlands (pb)	1-85937-289-9	£9.99
Oxfordshire (pb)	1-85937-430-1	£9.99	West Sussex	1-85937-148-5	£14.99
Peak District (pb)	1-85937-280-5	£9.99	West Yorkshire (pb)	1-85937-201-5	£9.99
Penzance	1-85937-069-1	£12.99	Weymouth (pb)	1-85937-209-0	£9.99
Peterborough (pb)	1-85937-219-8	£9.99	Wiltshire (pb)	1-85937-277-5	£9.99
Piers	1-85937-237-6	£17.99	Wiltshire Churches (pb)	1-85937-171-x	£9.99
Plymouth	1-85937-119-1	£12.99	Wiltshire Living Memories	1-85937-245-7	£14.99
Poole & Sandbanks (pb)	1-85937-251-1	£9.99	Winchester (pb)	1-85937-428-x	£9.99
Preston (pb)	1-85937-212-0	£9.99	Windmills & Watermills	1-85937-242-2	£17.99
Reading (pb)	1-85937-238-4	£9.99	Worcester (pb)	1-85937-165-5	£9.99
Romford (pb)	1-85937-319-4	£9.99	Worcestershire	1-85937-152-3	£14.99
Salisbury (pb)	1-85937-239-2	£9.99	York (pb)	1-85937-199-x	£9.99
Scarborough (pb)	1-85937-379-8	£9.99	Yorkshire (pb)	1-85937-186-8	£9.99
St Albans (pb)	1-85937-341-0	£9.99	Yorkshire Living Memories	1-85937-166-3	£14.99

See Frith books on the internet www.francisfrith.co.uk

FRITH PRODUCTS & SERVICES

Francis Frith would doubtless be pleased to know that the pioneering publishing venture he started in 1860 still continues today. A hundred and forty years later, The Francis Frith Collection continues in the same innovative tradition and is now one of the foremost publishers of vintage photographs in the world. Some of the current activities include:

Interior Decoration

Today Frith's photographs can be seen framed and as giant wall murals in thousands of pubs, restaurants, hotels, banks, retail stores and other public buildings throughout the country. In every case they enhance the unique local atmosphere of the places they depict and provide reminders of gentler days in an increasingly busy and frenetic world.

Product Promotions

Frith products are used by many major companies to promote the sales of their own products or to reinforce their own history and heritage. Frith promotions have been used by Hovis bread, Courage beers, Scots Porage Oats, Colman's mustard, Cadbury's foods, Mellow Birds coffee, Dunhill pipe tobacco, Guinness, and Bulmer's Cider.

Genealogy and Family History

As the interest in family history and roots grows world-wide, more and more people are turning to Frith's photographs of Great Britain for images of the towns, villages and streets where their ancestors lived; and, of course, photographs of the churches and chapels where their ancestors were christened, married and buried are an essential part of every genealogy tree and family album.

Frith Products

All Frith photographs are available Framed or just as Mounted Prints and Posters (size 23 x 16 inches). These may be ordered from the address below. From time to time other products - Address Books, Calendars, Table Mats, etc - are available.

The Internet

Already twenty thousand Frith photographs can be viewed and purchased on the internet through the Frith websites and a myriad of partner sites.

For more detailed information on Frith companies and products, look at these sites:

www.francisfrith.co.uk
www.francisfrith.com
(for North American visitors)

See the complete list of Frith Books at:

www.francisfrith.co.uk

This web site is regularly updated with the latest list of publications from the Frith Book Company. If you wish to buy books relating to another part of the country that your local bookshop does not stock, you may purchase on-line.

For further information, trade, or author enquiries please contact us at the address below:
The Francis Frith Collection, Frith's Barn, Teffont, Salisbury, Wiltshire, England SP3 5QP.
Tel: +44 (0)1722 716 376 Fax: +44 (0)1722 716 881 Email: sales@francisfrith.co.uk

See Frith books on the internet www.francisfrith.co.uk

TO RECEIVE YOUR FREE MOUNTED PRINT

Mounted Print
Overall size 14 x 11 inches

Cut out this Voucher and return it with your remittance for £1.95 to cover postage and handling, to UK addresses. For overseas addresses please include £4.00 post and handling. Choose any photograph included in this book. Your SEPIA print will be A4 in size, and mounted in a cream mount with burgundy rule line, overall size 14 x 11 inches.

Order additional Mounted Prints at HALF PRICE (only £7.49 each*)

If there are further pictures you would like to order, possibly as gifts for friends and family, purchase them at half price (no additional postage and handling required).

Have your Mounted Prints framed*

For an additional £14.95 per print you can have your chosen Mounted Print framed in an elegant polished wood and gilt moulding, overall size 16 x 13 inches (no additional postage and handling required).

*** IMPORTANT!**
These special prices are only available if ordered using the original voucher on this page (no copies permitted) and at the same time as your free Mounted Print, for delivery to the same address

Frith Collectors' Guild

From time to time we publish a magazine of news and stories about Frith photographs and further special offers of Frith products. If you would like 12 months FREE membership, please return this form.

Send completed forms to:
The Francis Frith Collection, Frith's Barn, Teffont, Salisbury, Wiltshire SP3 5QP

Voucher for FREE and Reduced Price Frith Prints

Picture no.	Page number	Qty	Mounted @ £7.49	Framed + £14.95	Total Cost
		1	**Free of charge***	£	£
			£7.49	£	£
			£7.49	£	£
			£7.49	£	£
			£7.49	£	£
			£7.49	£	£

Please allow 28 days for delivery	*** Post & handling**	**£1.95**
Book Title	**Total Order Cost**	**£**

Please do not photocopy this voucher. Only the original is valid, so please cut it out and return it to us.

I enclose a cheque / postal order for £
made payable to 'The Francis Frith Collection'
OR please debit my Mastercard / Visa / Switch / Amex card
(credit cards please on all overseas orders)

Number .

Issue No(Switch only)Valid from (Amex/Switch)

Expires Signature .

Name Mr/Mrs/Ms .

Address .

. .

. Postcode

Daytime Tel No . Valid to 31/12/02

The Francis Frith Collectors' Guild

Please enrol me as a member for 12 months free of charge.

Name Mr/Mrs/Ms .

Address .

. .

. .

. Postcode

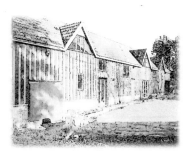

Would you like to find out more about Francis Frith?

We have recently recruited some entertaining speakers who are happy to visit local groups, clubs and societies to give an illustrated talk documenting Frith's travels and photographs. If you are a member of such a group and are interested in hosting a presentation, we would love to hear from you.

Our speakers bring with them a small selection of our local town and county books, together with sample prints. They are happy to take orders. A small proportion of the order value is donated to the group who have hosted the presentation. The talks are therefore an excellent way of fundraising for small groups and societies.

Can you help us with information about any of the Frith photographs in this book?

We are gradually compiling an historical record for each of the photographs in the Frith archive. It is always fascinating to find out the names of the people shown in the pictures, as well as insights into the shops, buildings and other features depicted.

If you recognize anyone in the photographs in this book, or if you have information not already included in the author's caption, do let us know. We would love to hear from you, and will try to publish it in future books or articles.

Our production team

Frith books are produced by a small dedicated team at offices in the converted Grade II listed 18th-century barn at Teffont near Salisbury, illustrated above. Most have worked with the Frith Collection for many years. All have in common one quality: they have a passion for the Frith Collection. The team is constantly expanding, but currently includes:

Jason Buck, John Buck, Douglas Burns, Heather Crisp, Isobel Hall, Rob Hames, Hazel Heaton, Peter Horne, James Kinnear, Tina Leary, Hannah Marsh, Eliza Sackett, Terence Sackett, Sandra Sanger, Shelley Tolcher, Susanna Walker, Clive Wathen and Jenny Wathen.